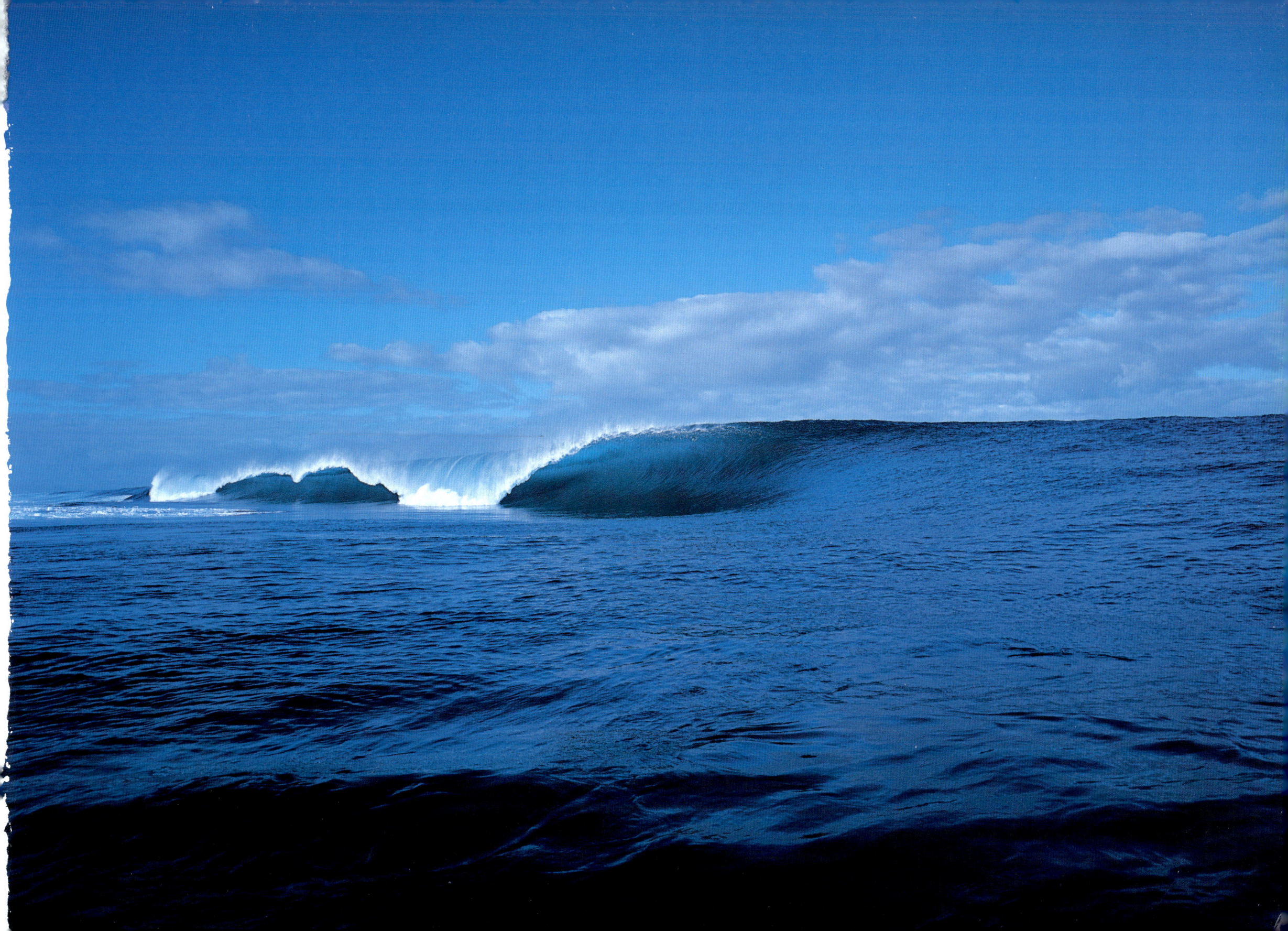

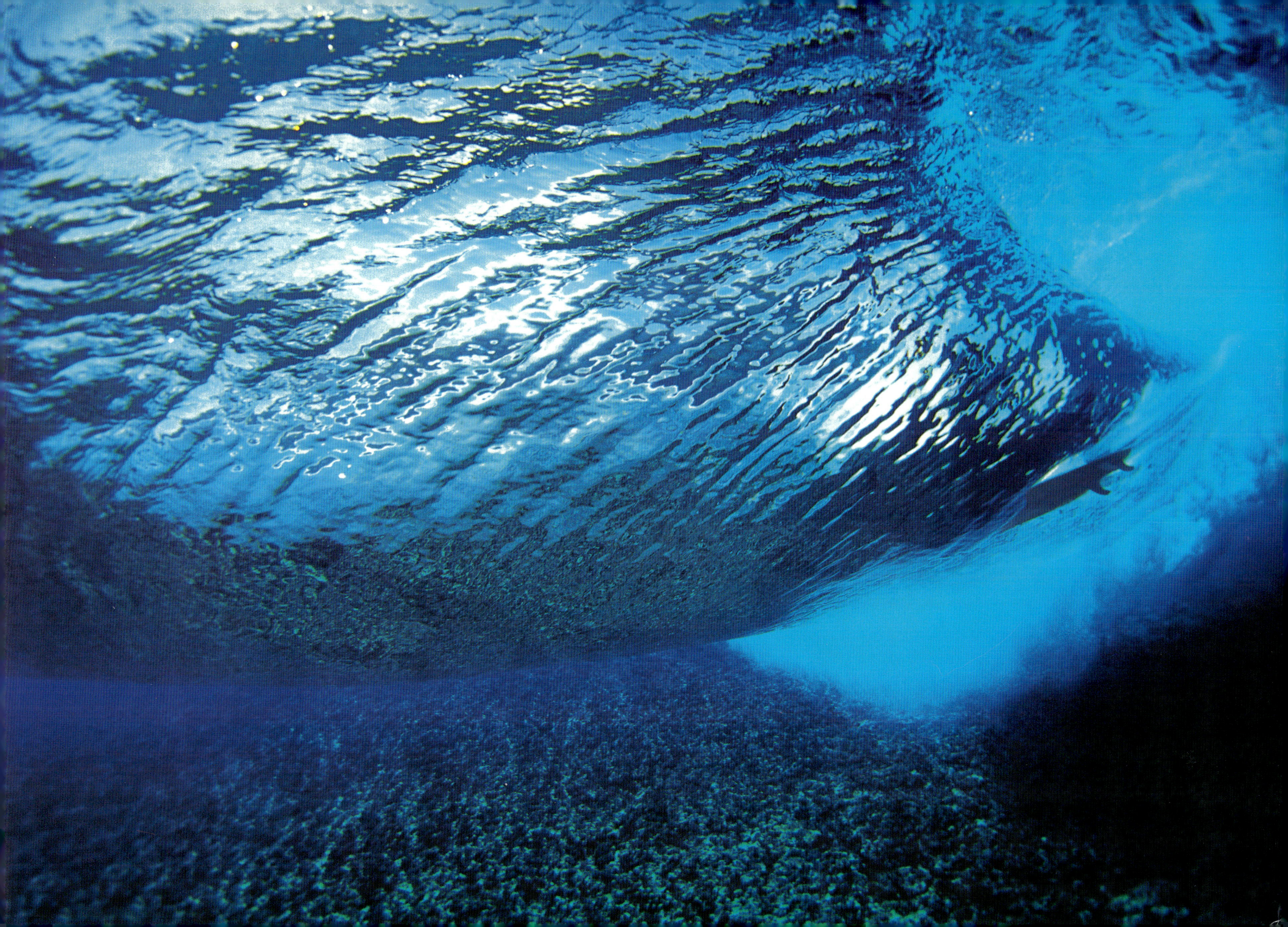

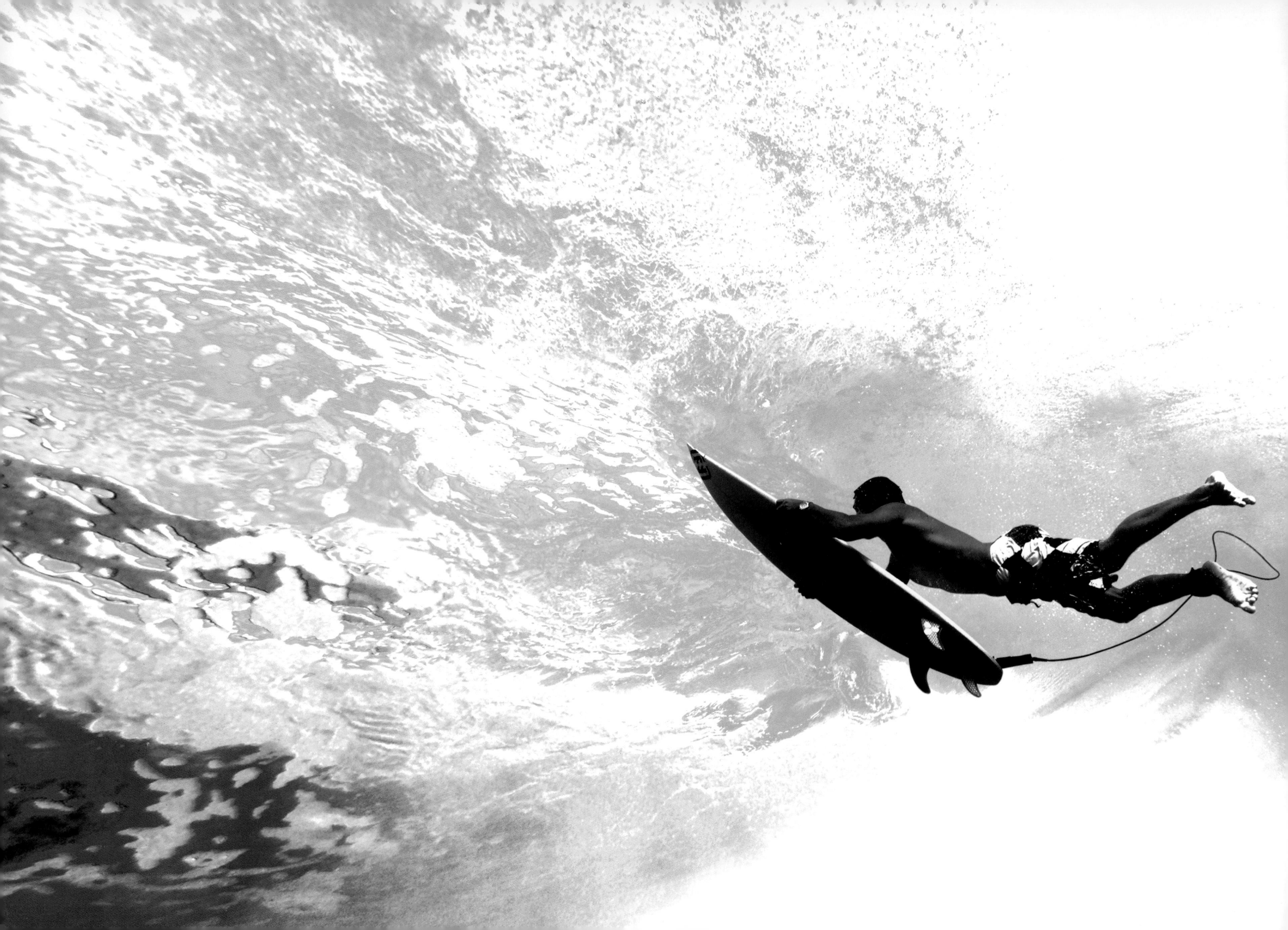

teahupoo
tahiti's mythic wave tim mckenna

The Legend *'ā'ai*

Perfection *fa'ahiahia*
manoa DROLLET

Fear *ri'ari'a*
garrett McNAMARA

The Challenge *tāmata*
kelly SLATER - andy IRONS

Glory *hanahana*
shane DORIAN - laird HAMILTON

Heritage *tamari'i 'āi'a*
raimana VAN BASTOLAER - vetea DAVID

Playground *vāhi ha'utira'a*

Mana *mana*
malik JOYEUX

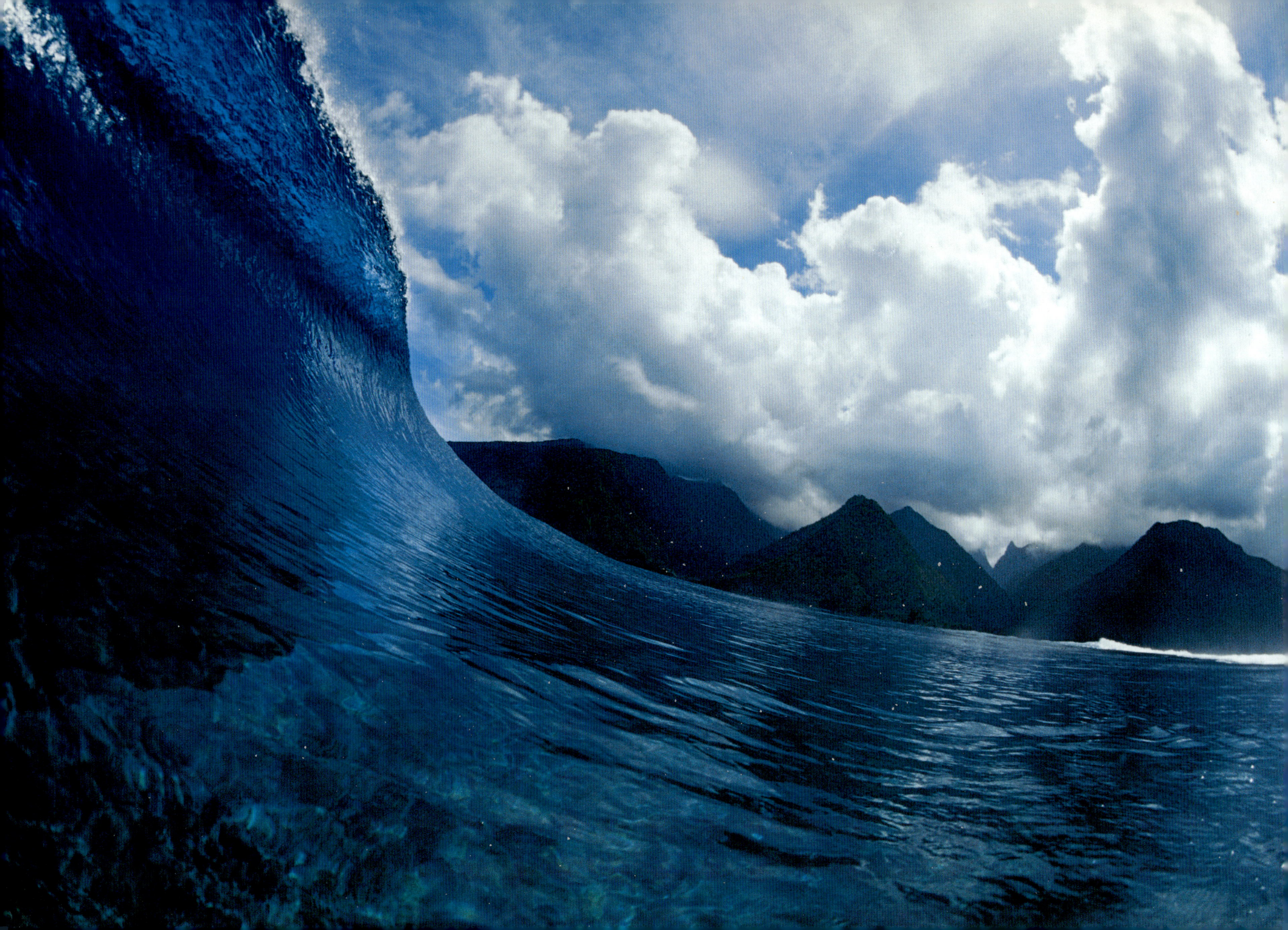

Foreword

Jack McCoy

There I was, lying there like a stunned mullet, seeing stars and listening to the cuckoo clock in the background going "Cuckoo! Cuckoo!" I was talking to myself, having this little chat, almost disbelieving what had just happened. "Boy oh boy, that was a hard hit to the head." Pause, a little time reflecting.... "Wow, I've never been hit so hard before."... pause ... "That was gnarly! How's the camera? Let me see. Yes, still in my hand here, that's good." Another pause.... "Wow, that was the hardest I've ever been hit in the head." Then it came to me: "Hey man, you're underwater! Really? Ok ... but that *was* a heavy hit to the head, and now that I think about it, the shoulder too." The conversation started to speed up a bit. "Hey, you've got to get to the surface. Yeah but ... that hit to the head was *soooooooo* hard." About then, all those Surf Life Saving courses kicked in. "Ok, move your fingers, wiggle your toes. Yep, all good." "You need to come up." "Yeah, I know ... but the hit to the ..." "Get up NOW!" "Ok."

I staggered to stand up. The reef was not that sharp where I was, but it was still hard to get my footing.

To cut a long story short, after an adrenalin-fueled dash through a gap in the reef, the whole time praying a set of waves would not come through, I swam to the boat for help. A friend put me on my jet-ski sled then sat a big Tahitian on top of me, whereupon I passed out cold for about half an hour. Luckily, there was an emergency-room specialist on the beach who was visiting from California. He brought me around and stitched up a big gash under my neck.

I had been filming Andy Irons that afternoon. The surf had been almost flat for a couple of days and it was starting to come up for the Billabong Pro world tour event. I had decided to move down to the inside of the reef to try and get a better angle on Andy who was getting these little tubes that were running further inside than normal, because of the straight southerly direction of the swell. Andy took off on this one wave – it had come more from the west. I was in shallow water almost standing. The water was draining off the reef making it more and more shallow. It basically wedged up creating a peak that Andy decided to go around before sliding over the back of the wave.

I'd already committed to the shot by turning the camera on and following him with it as he pulled out. Then I did what I've done thousands of times before: I pushed off the bottom and dived into the face of the wave to let it pass over me. In what seemed like a split second, I was picked up and thrown head first onto the reef. The blow was so powerful I'm amazed I wasn't knocked out. I hit the left side of my helmet so hard that it split my neck open just below my jaw. My right shoulder also took the blow, big time! It was then while probably under two feet of water, that I started having that little conversation with myself.

By surfing standards it was only a small wave, around four to five feet. But this was no ordinary wave, and no ordinary surf spot. This was Teahupoo, one of the most beautiful and unique waves I'd ever seen, and one of the world's most dangerous. At this spot the deep water swell heads towards the shallow reef, and as it approaches, the water on the inside of the reef drains out to sea to meet it. As the swell hits the reef, a freak of nature creates the thickest, meanest, hollowest wave; a wave like no other yet found on

earth; a wave that peels along the reef with such perfection that it's what millions of dreams (or nightmares) are made of.

Approximately 50 years ago, another wave captured the imagination of the surfing world. It was located on the Hawaiian island of Oahu's now famous North Shore, and is known as the Banzai Pipeline. Until the early 1960s, the break was considered "unsurfable." The words Banzai Pipeline sent shivers down the surfers' spines. It was a big, hollow, shallow and very dangerous wave unlike any other. Finally it was surfed, and with the radical change in surfboards in the late 60s, it became one of the world's most challenging surf spots. For years, Pipeline reigned supreme as the biggest, thickest, roundest, gnarliest tube in the surfing world.

That was until the late 1980s, when a few Tahitian locals started to surf a reef about a mile offshore from the sleepy village of Teahupoo, at the end of the road that runs down the promontory called Tahiti Iti, at the southern tip of the island of Tahiti. Nowadays surfers come from all points of the globe to ride the small, medium, big and the psycho days. The dangers are always present no matter what the size. Respect for the wave is mandatory.

My relationship with Teahupoo started in 1993 when an Aussie ex-pat, Dave Kelly, took Mark Occhilupo, Sunny Garcia, Pancho Sullivan and myself out to the break in a local friend's boat. This day was also small. We all ended up on the reef at one stage or another and decided it wasn't really the place we wanted to surf or shoot film.

My next trip to Tahiti would be at the invitation of the French sportswear company Oxbow where I'd be working with Tim McKenna to shoot footage for a promotional program for them. Tim and I were friends from other Oxbow trips we'd done together after having met in Indonesia in 1994. We had a lot in common, had a lot fun together and respected each other's work.

But it would be this trip to Tahiti where fate would have us both doing what we do best when Laird Hamilton rode "that wave." Together, with Laird's blessing, we sent out the vision of that historic day and ride. That session really broke the sound barrier and was to go down in history, I believe, as the greatest wave ever ridden ... by the only human who could have ridden it. Although Tim had completed many photographic assignments in this part of the world over the years, this day would be the start of his commitment to documenting this phenomenon known as Teahupoo. Since that day in August 2000, he has set up his life so that he can be there to record the days that provide surfers and spectators alike with the greatest show on earth.

Whether sitting in the channel in Emile's boat, hanging out of a helicopter, or swimming with his camera in its water housing, Tim has captured the spirit of Teahupoo like no other. His love for Tahiti, its people, its culture, its waters and waves is reflected in this wonderful collection of photographs: Teahupoo, one of the most terrifyingly beautiful freaks of Nature.

"When old King Neptune's raising hell and the breakers roll sky high, let's drink to those who can ride that stuff and to the rest who are willing to try."

John Heath 'Doc' Ball.

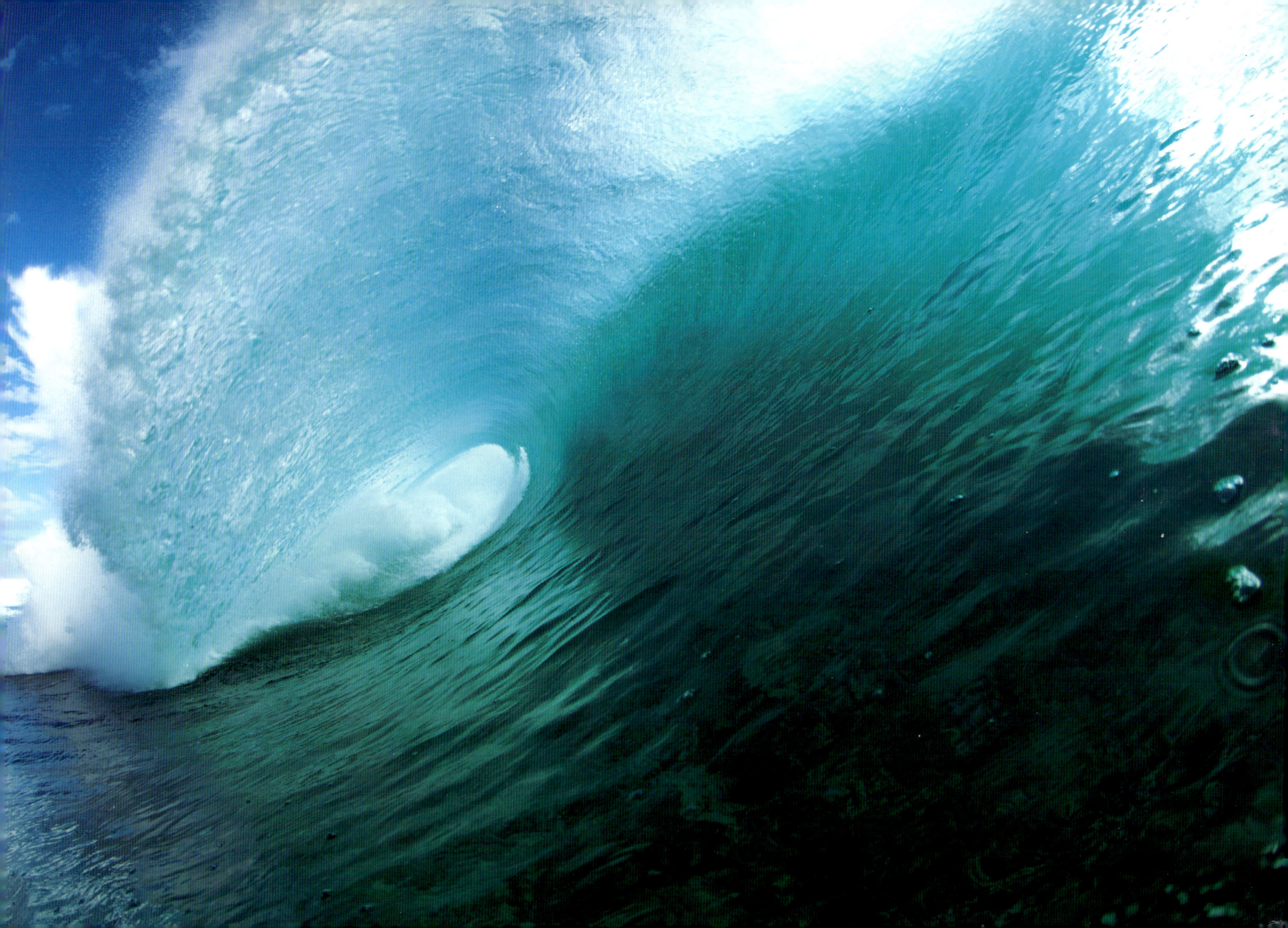

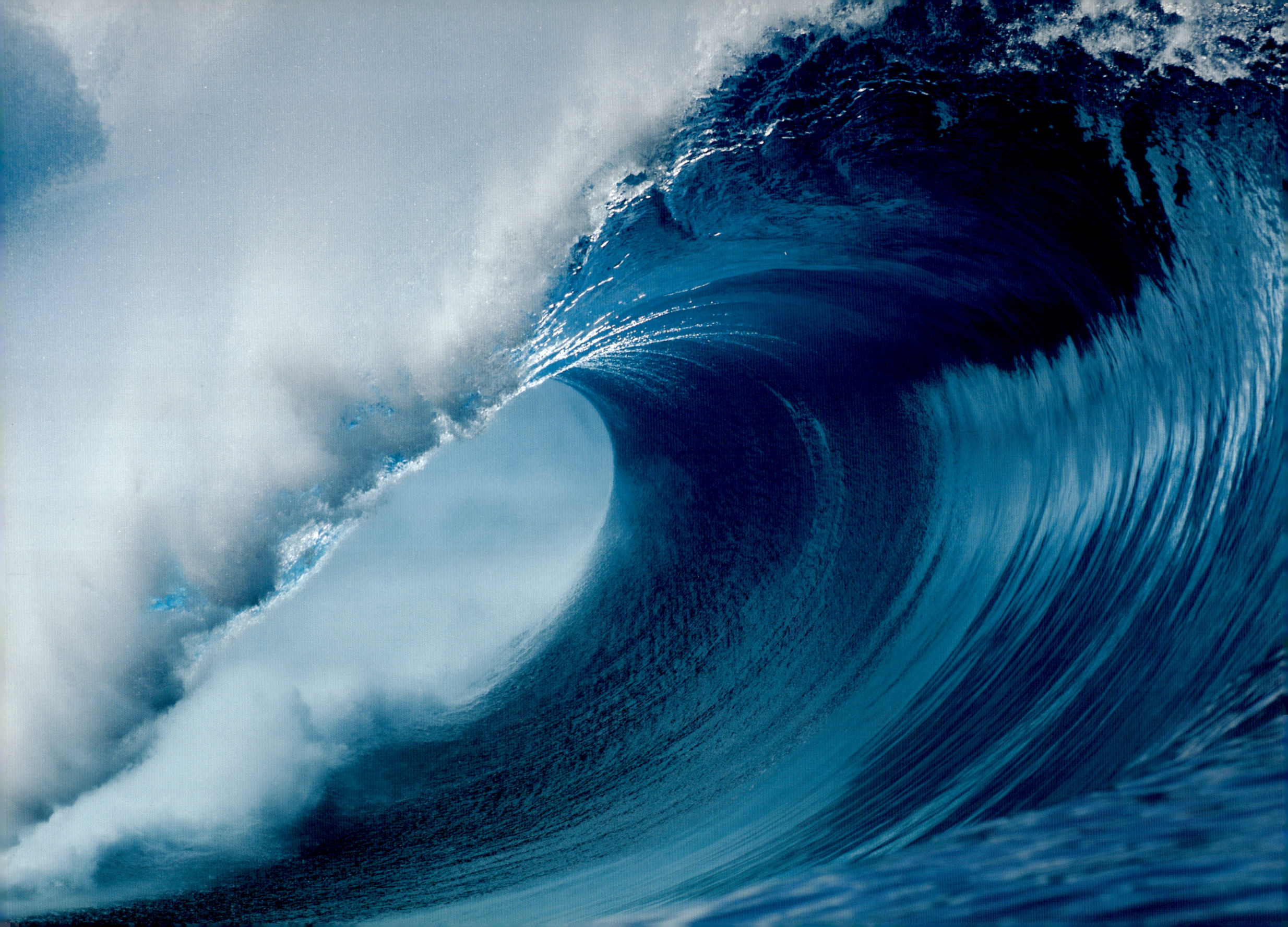

Preface
Tim McKenna

The ocean has always had a hypnotic effect on me and in particular the mechanics of breaking waves. This fascination started on the beaches of southwest France, where I spent most of my childhood, and developed in Australia during my university years. Since then, throughout my career as a photographer, I have been commissioned for many worldwide assignments offering me a unique insight into our planet's oceans. The stability yet perpetual motion of the ocean is a gift of nature, reassuring us in this fast, chaotic world.

As a photographer, I am constantly in search of those rare moments where nature becomes art. It is the ephemeral nature of these events that makes each image unique and gives it exceptional appeal.

One day in 1996 I was introduced to one of nature's miracles and decided to document its every move. "The Wave at the End of the Road" at Teahupoo was awe-inspiring and addictive. Nothing compares with the adrenaline rush provoked by the proximity of this massive wave and feeling against your face the thrust of the air compressed by the tube, whether in the relative safety of a fishing boat, swimming in the waves capturing different water angles or getting caught by a wide set. Shooting from a helicopter when the line-up and channel are too packed for unobstructed shots is equally exhilarating. And then there is of course the rush of participating actively in the incredible performances of great athletes.

This book is an invitation into a very special universe, full of privileged moments when all the elements fall into place and create a masterpiece as powerful as it is beautiful. Go to Teahupoo on a calm day and the wave itself might be disappointing from a surfing point of view, yet the surroundings will instantly fill your soul. Come back on another day and the same wave will have turned into the most incredible show on earth.

It is a show in which the wave is the star as much as the athlete and Teahupoo carefully chooses the stars whom it touches with a spirit or *mana*. When this spirit stirs, the surfer is transported into its magical realm. Finally in harmony with nature, he can extend his limits, safe in the knowledge that survival and even victory are within his grasp.

I have dedicated the last ten years to documenting every major swell at Teahupoo. I soon realized that my efforts could greatly help the exposure and thus the careers of the local Tahitian surfers. They are great watermen, humble, dedicated and respectful of the ocean. Their talent is as unique as the wave with which they have been blessed. They should be the first to benefit from the enormous media attention generated by Teahupoo.

Although the ocean is the most powerful element on our planet, it is nevertheless vulnerable. Respect for it is the duty of all. The evanescent but ever-renewed beauty of the Teahupoo wave, intensified by its awesome power, teaches us to respect life and the environment. The wave is a true miracle, inviting us to see things the right way and to act accordingly.

'ā'ai

fa'ahiahia

ri'ari'a

tāmata

hanahana

tamari'i 'āi'a

vāhi ha'utira'a

mana

The Legend

In ancient times was born on the island of Raiatea the cult of Oro, god of war and fertility, son of Taaroa, the Creator. Overlooking Opoa Bay, a sacred enclosure of stones, known as a *marae*, was created in his honour on a remote site with magical attributes. It was from this *marae*, called *Taputapuatea*, that priests went out in their sacred outriggers to spread the new religion throughout the archipelago. These messengers of Oro, known as *arioi*, were thought to have come from the world of the dead and, although sacred, were in fact fearsomely cruel warriors who subjected the conquered populations to horrible atrocities.

At this time, the districts of Teahupoo – previously called Matahihae, which means "eyes flashing with anger" – and Tautira were divided into smaller entities controlled by local chieftains who constantly fought among themselves for hegemony.

On one occasion, a famous battle over boundaries broke out on the promontory of Taiarapu between the districts of Tautira and Matahihae. Much blood was shed. The god Oro was very fond of the flesh of slain warriors but, for practical reasons, only the heads were carried off and placed in the *marae* to dry and bleach along with the stones. The victorious southern warriors, after decapitating their opponents, created a wall (*ahu*) of heads (*upo'o*) on the boundary at a place called Rapa'e. The village of *Te-ahu-upo'o*, now contracted to *Teahupoo*, thus gets its name from the wall of skulls erected by these belligerent ancestors.

In the Polynesian oral tradition, based essentially on the use of images and metaphors, it is obvious that the destructive power of the mythical Teahupoo wave is a metaphor for the violence of the *arioi* warriors who bestowed its symbolic name. Only a violent, bloody and pitiless wave was capable of assuming such a barbaric heritage. And only a new and powerful legend could transcend the original one featuring a collection of skulls. The ancients had already made the parallel between cruelty in war and the fury of the wave since, in the incantations preceding human sacrifices, the victorious chieftains used to incite the executioners to greater valor by chanting," Be like the raging ocean."

Although originating in centuries past, in another language and in a different context, the myths and legends which have stood the test of time can still have a message for us. As long as the legend remains alive in the oral tradition, the mythical narrative has not taken on its definitive form and can undergo many variations over time, at the whim of the narrator. This is how modern legends like that of the Teahupoo wave are grafted onto past myths.

Since time immemorial, surfers have inscribed their own myths on the waves. A definite culture has evolved from these, now transmitted by filmmakers, historians and other writers but also by a vibrant oral tradition. Teahupoo's waves, like the great battles of yesteryear, are the subject of conversations and speculation the world over. It is this new legend which we have the honor of recounting and which is called: *Teahupoo: Tahiti's Mythical Wave*.

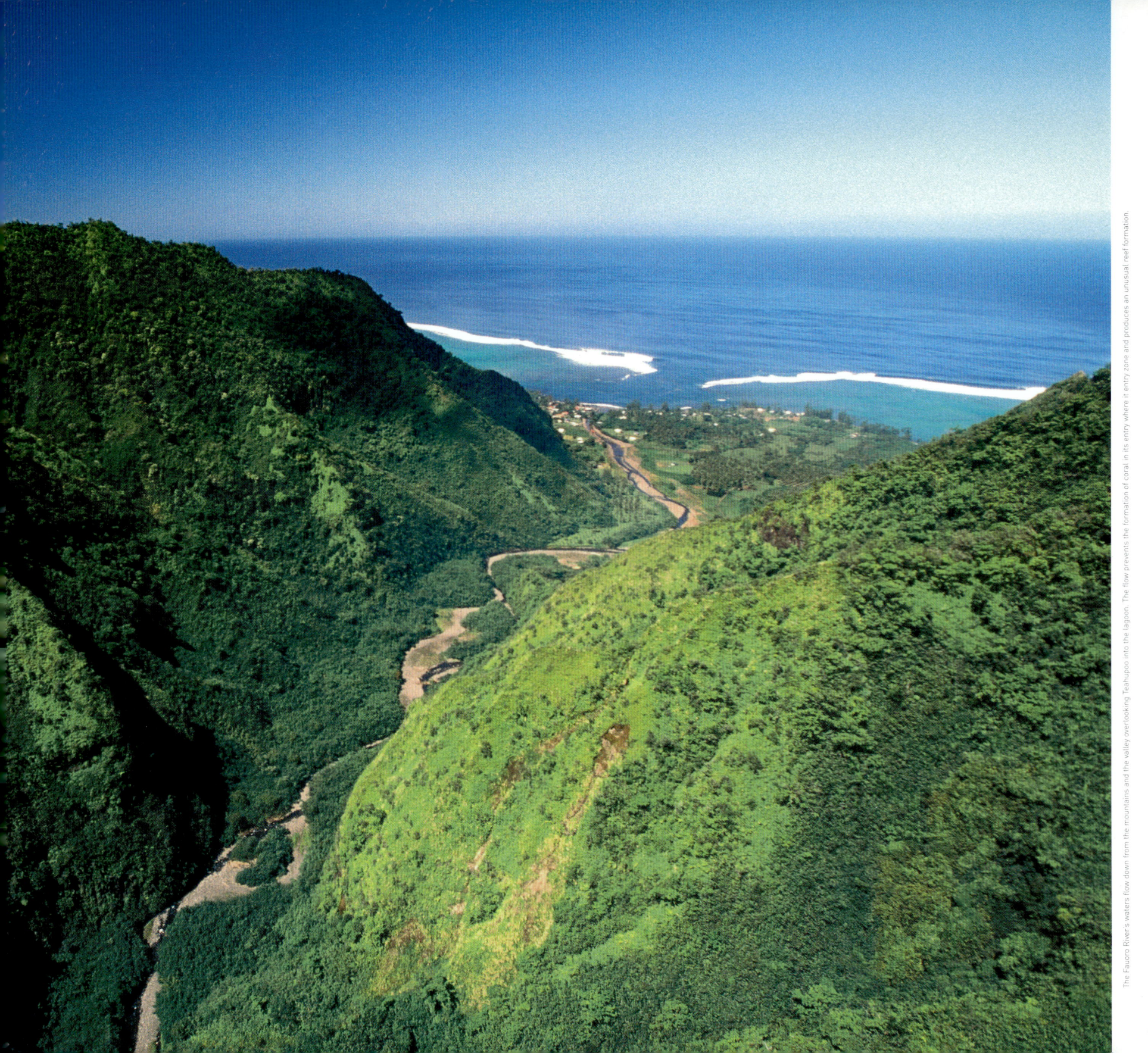

The Fauaro River's waters flow down from the mountains and the valley overlooking Teahupoo into the lagoon. The flow prevents the formation of coral in its entry zone and produces an unusual reef formation.

"All day, the wind blew on the sea. And the sea became grey under a grey sky. All day, the waves attacked the beach and the cliff, snatching away sand and stones. But under the sand there was still more sand and behind the stones there were still more stones. Defeated and weary, the sea withdrew at nightfall. Now completely calm, it shone brightly in the starlight. Along the reef, a few solitary waves made the coral resonate, in a vain attempt to reach the moon."

This is the beginning of the Polynesian legend of the Creation of the Waves, found in various forms in many Pacific islands. Taaroa, the Great Architect, created the ocean smooth, without any movement or wrinkles. The sea got bored and began to rise slowly in an attempt to cover the whole earth, even though it knew that this was forbidden. It was allowed to cover only half of the globe, the rest belonging to stones, trees and men. It carefully avoided any sacred places to which a taboo was attached so as not to awaken the gods. It thus increased its domain by slipping around the obstacle, creating an island. A warrior called Arai decided to stop the sea in order to save his village. Risking his life, he took a stone from the *marae* and hid it under the sand. The sea began to rise but, not seeing the danger, it covered the sacred stone. When the gods found out, they exploded in anger and a thunderclap stopped the sea in its tracks. Since that day, men and the sea have constantly defied one another. The sea would like to swallow them up but each time that it makes a move, it creates a multitude of waves and the noise warns humans of the danger.

Another legend concerns Vehiatua, "the beauty who rides the waves." She was a young girl of immense beauty who came from Raiatea. While visiting Tahiti with three female friends she heard about a celebration organized by the people of Teahupoo in honor of surf, *horue*. Since she was famous as a wave-rider in her own country she expressed a wish to enter the competition. The *faatere*, or master of ceremonies, warned the young girls, "Prepare yourselves well because you will have to surf in front of many people. You will be scrutinized by innumerable pairs of eyes and criticized by innumerable tongues."

On the great day, handsome young men came from all parts of Tahiti to surf the waves, each trying to outdo the other. Vehiatua and her friends waited on the shore, suffering the mockery and provocations of the crowd. However, they noticed that the surfers had been swept off course by the current and were waiting for it to weaken before confronting the

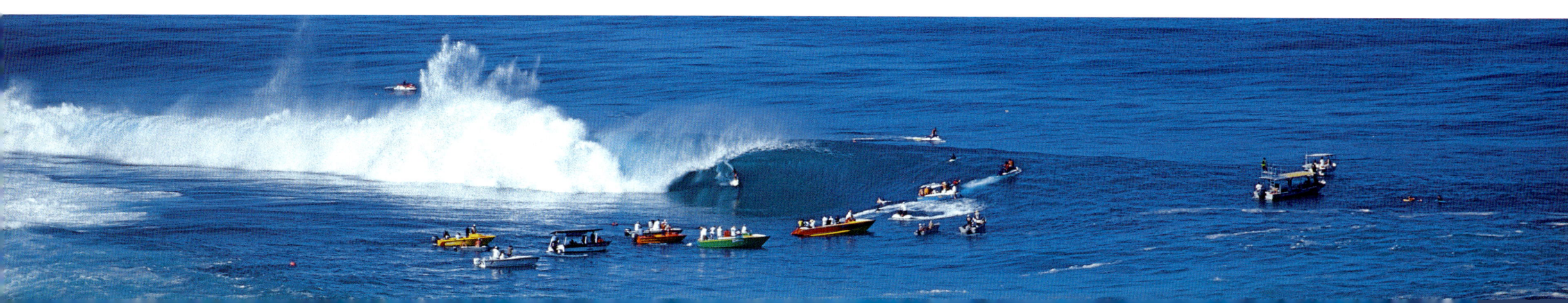

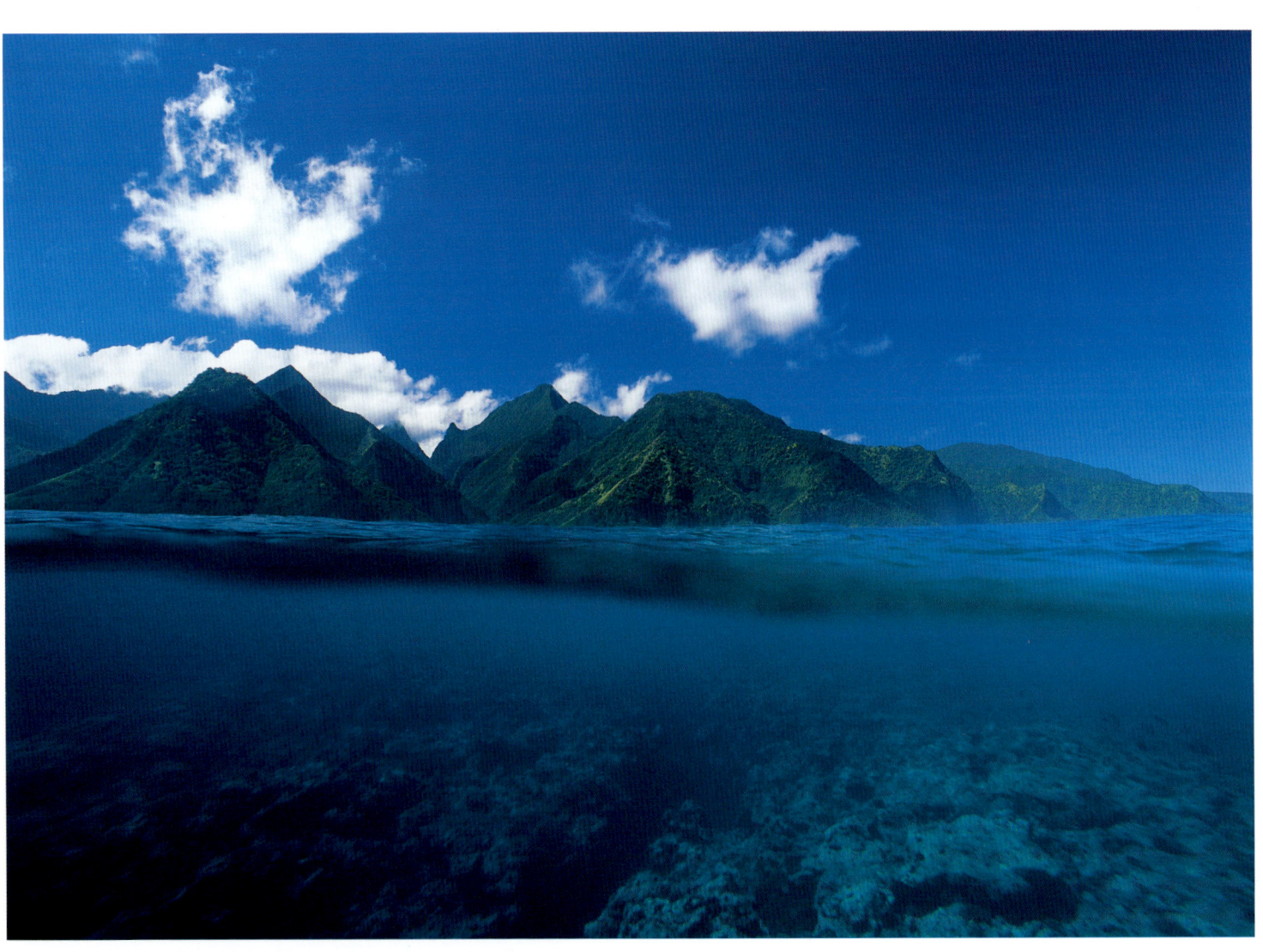

huatau, "the wave which breaks abruptly on the reef." When the sun rose higher in the sky, the *Arue roa*, the gentle southwest wind arose, and Vehiatua and her friends paddled out well beyond the usual take-off zone. A huge wave came, which they were able to surf superbly, and the crowd applauded them. Furious, the *ari'i*, chief of the village, Teihe the Vain, chased Vehiatua away and took her name so that no one other than he should be acclaimed at Teahupoo.

At the opening ceremony of the first international competition organized in Tahiti in 1997, one of the village elders, Tauirarii Rochette, known as Zorro, related this legend to the crowd. Other myths testify to an abundant oral tradition concerning surf at Teahupoo, for example that of the princess Hinaraure'a, who surfed "on a flat fish" or of the king who imprisoned his daughter in a cave guarded by lizards so that she could only be courted by surfing at the Hava'e channel on a big swell.

A legend is a mixture of the true and the false but is always based on one or two real events. It is often constructed in two phases: a real event that is then transformed into a legend by transposition or exaggeration. The legendary narrative is thus transformed to reinforce the narrative power and to

ensure transmission to posterity. A legend is a compendium of the anonymous and elusive scraps of hearsay generated in innumerable conversations and human exchanges.

Tahitian mythology has doubtless chosen to attach surfing legends to Teahupoo because the Hava'e reef has had a dangerous reputation since time immemorial. When modern surfers rediscovered it at the end of the 1980s, they quickly understood that they were in the presence of an extraordinary manifestation of nature's power, a tube quite as dangerous as the dragons and monsters of ancient mythologies. Hearsay has done the rest.

Like the ancient heroes who often enjoyed the complicity of the gods while retaining the weaknesses of men, the Teahupoo pioneers had to vie with each other in technique and audacity to produce exploits worthy of the wave. Some of them achieved worldwide status of demigods throughout the world because of their skill and *sang froid*. However, with all the respect due to their courage, they are only vehicles of the legend that has been transmitted across all the oceans over the last two decades. The real heroine of this Polynesian odyssey remains the Teahupoo wave itself, whose myth is only at its beginning.

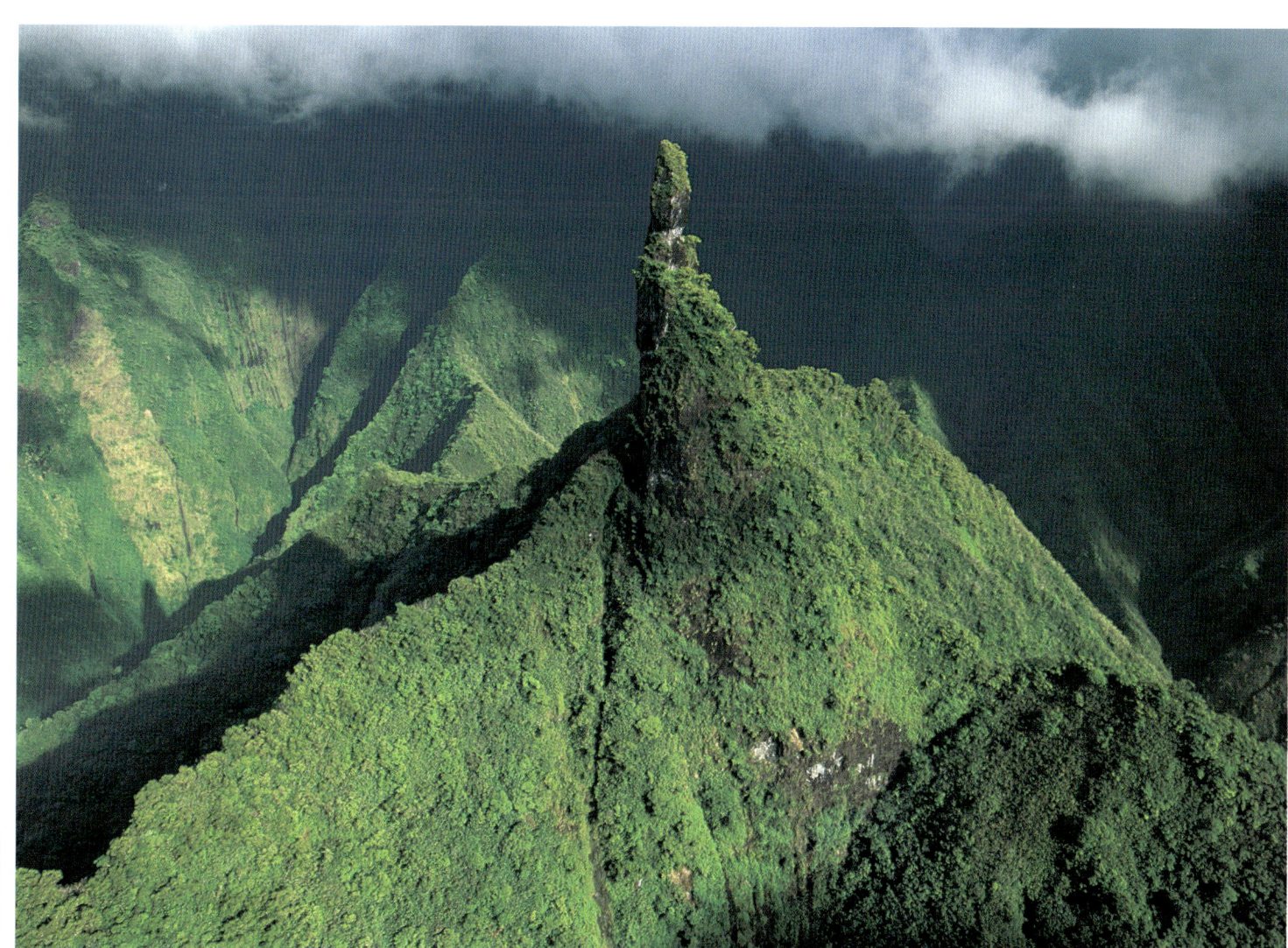

Mount te Ure vai arava.

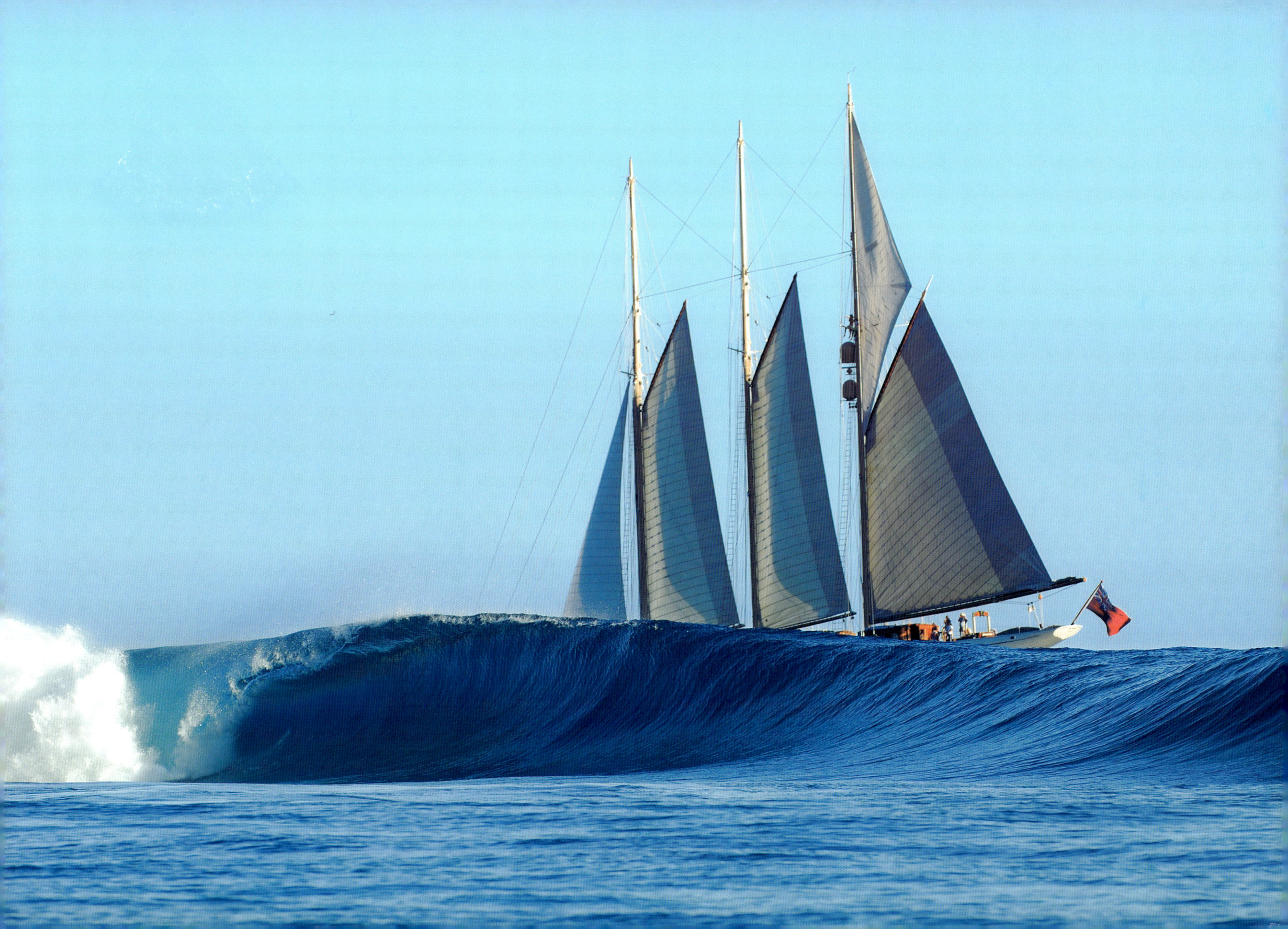

'ā'ai

fa'ahiahia

ri'ari'a

tāmata

hanahana

tamari'i 'āi'a

vāhi ha'utira'a

mana

Perfection

Every poet projects his own vision of perfection onto the ocean. Thousands of books have been written over the centuries about the sun setting over the sea, a tropical storm or a wave breaking on a reef. The power of the ocean has fascinated and inspired the imagination of innumerable writers.

In the great library of oceanic literature, Tahiti occupies a special place. Polynesia was the muse of such authors as Robert Louis Stevenson, Herman Melville, Pierre Loti, Victor Segalen, and Jack London, all of them head-over-heels in love with limitless horizons. They described sparkling lagoons, beaches of coral and black sand and the way the wind chased the clouds between the islands. Almost all of their work evokes the relationship between the Polynesian people and the ocean, as well as the importance of the lagoon. These authors chose Tahiti to illustrate the theme of Paradise, dazzled as they were by the wild and triumphant nature of this antipodean Eden. The word "perfection" appears everywhere in their works and assumes the status of a self-evident fact.

The wonderment of these romantic devotees of the southern seas is quite understandable. However, the urgency of their desire to convince is no excuse for vagueness. It is possible to conjure up an image of Paradise but perfection itself remains beyond all imagination. When this perfection does appear, as at Teahupoo, words are quite inadequate for dealing with the elements involved.

Added like a jewel to the peninsula of the island of Tahiti, the Teahupoo wave surpasses all others in beauty and perfection. Any description, no matter how detailed, always falls short of doing justice to its otherworldly qualities.

Imagine a wave that has served as a model for all others since the beginning of the world. It rears up from the depths like a cobra at the point where the sublime but terrifying southern swell meets a submerged wall of fire coral. When the accumulated force of the Pacific Ocean meets this natural obstacle, the water is sucked from the reef, leaving the sea level terrifyingly low. Teahupoo then rolls into and onto itself in slow motion, forming a cavern as high as it is wide, a true cathedral of light and salt water into which a possessed surfer occasionally slides, seeking to conclude, in this sacred place, his quest for the perfect wave.

The beauty of Teahupoo is a miracle which lasts but a single instant. Each drop of water seems in its right place in this ephemeral liquid sculpture as it rises skyward. The wall becomes momentarily a playground for transparency and mirror effects, then abandons its perfect shape and dislocates into myriad atoms with a thunderclap worthy of the end of the world. The lip cracks like a whip as it hurls itself onto the reef shelf and the tube unleashes an avalanche of spray, which reaches its own explosive apotheosis in the pass. And already the silhouette of the next wave throws its shadow on the reef.

There is something profoundly moving about the purity of the shape of a wave. Since the times of the ancient Greeks, the touchstone of beauty and perfection have been the sphere and the two-dimensional circle, which are models of pure symmetry. The Teahupoo tube defies mathematics as much as it does our understanding.

The idea of perfection, which it embodies can even lead to a wider metaphysical principle and even to religious and philosophical considerations. Its power of fascination is such that one finishes by conferring a living identity on the wave, lending it consciousness and divine intentions.

Surfers, human and thus imperfect, choose to confront their own lives with the perfection of Teahupoo, and thus deserve more respect than writers. For they are the only ones to have caught a glimpse, in this far reach of Polynesia, of a more perfect Paradise than that found in books.

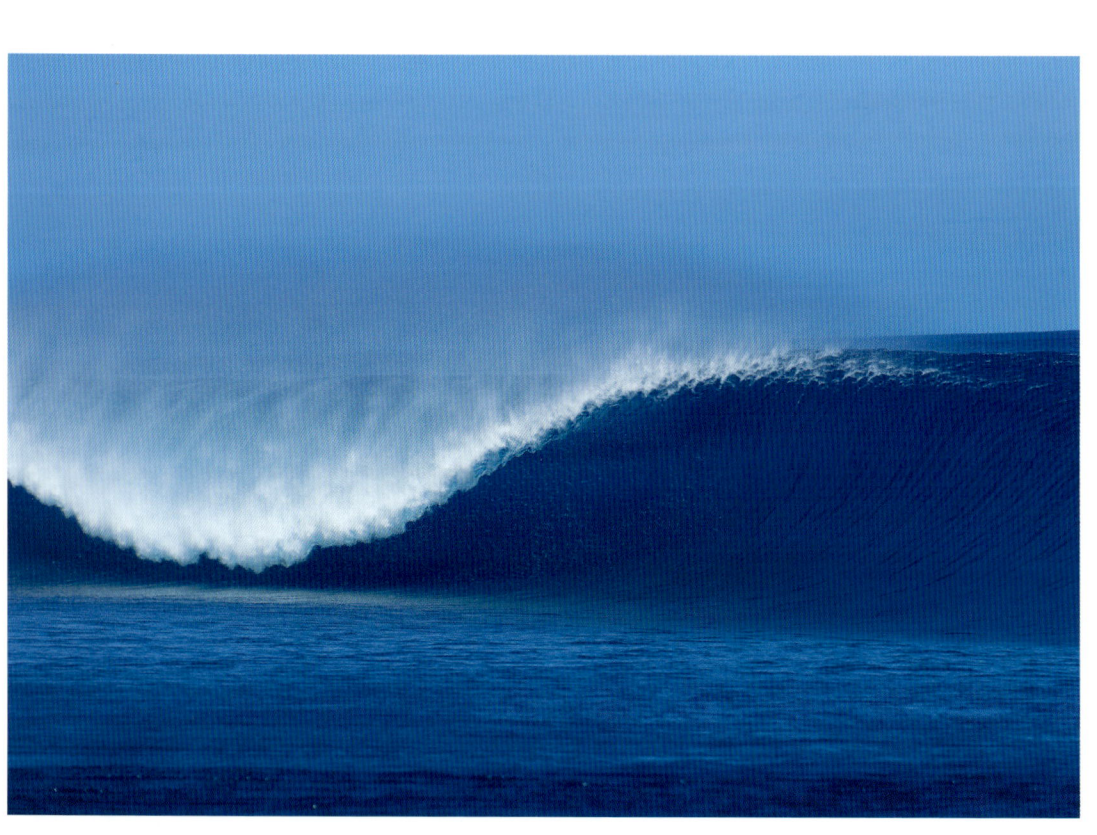
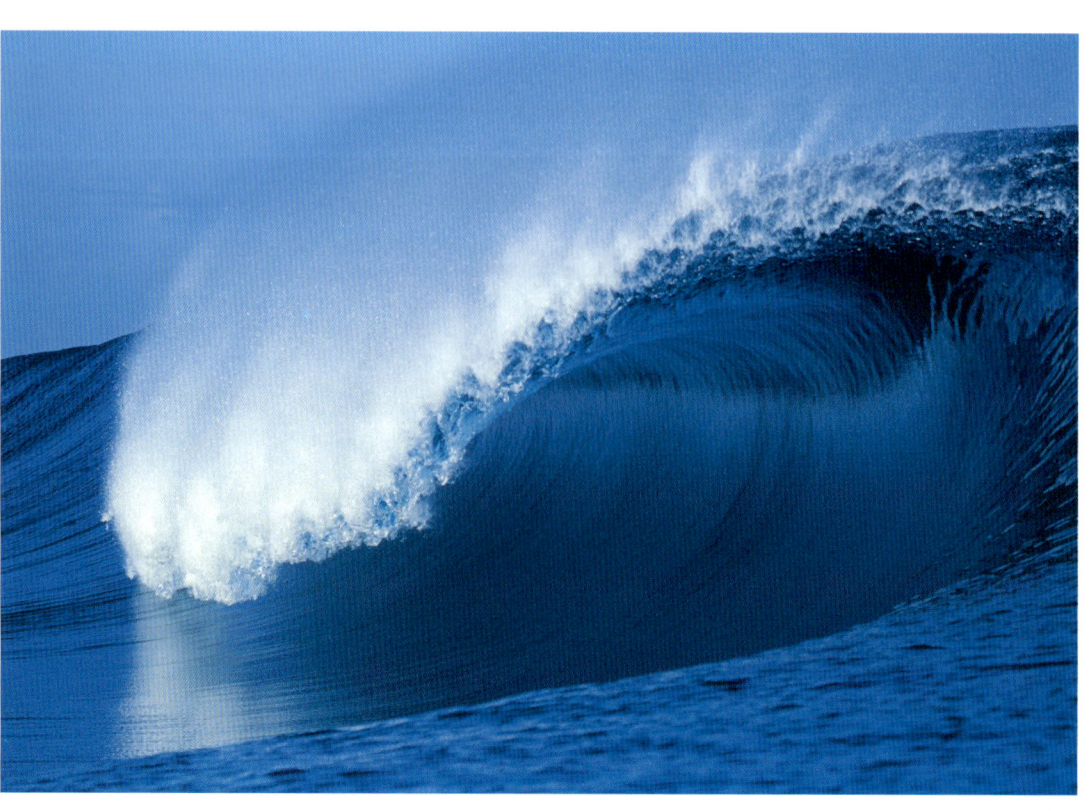

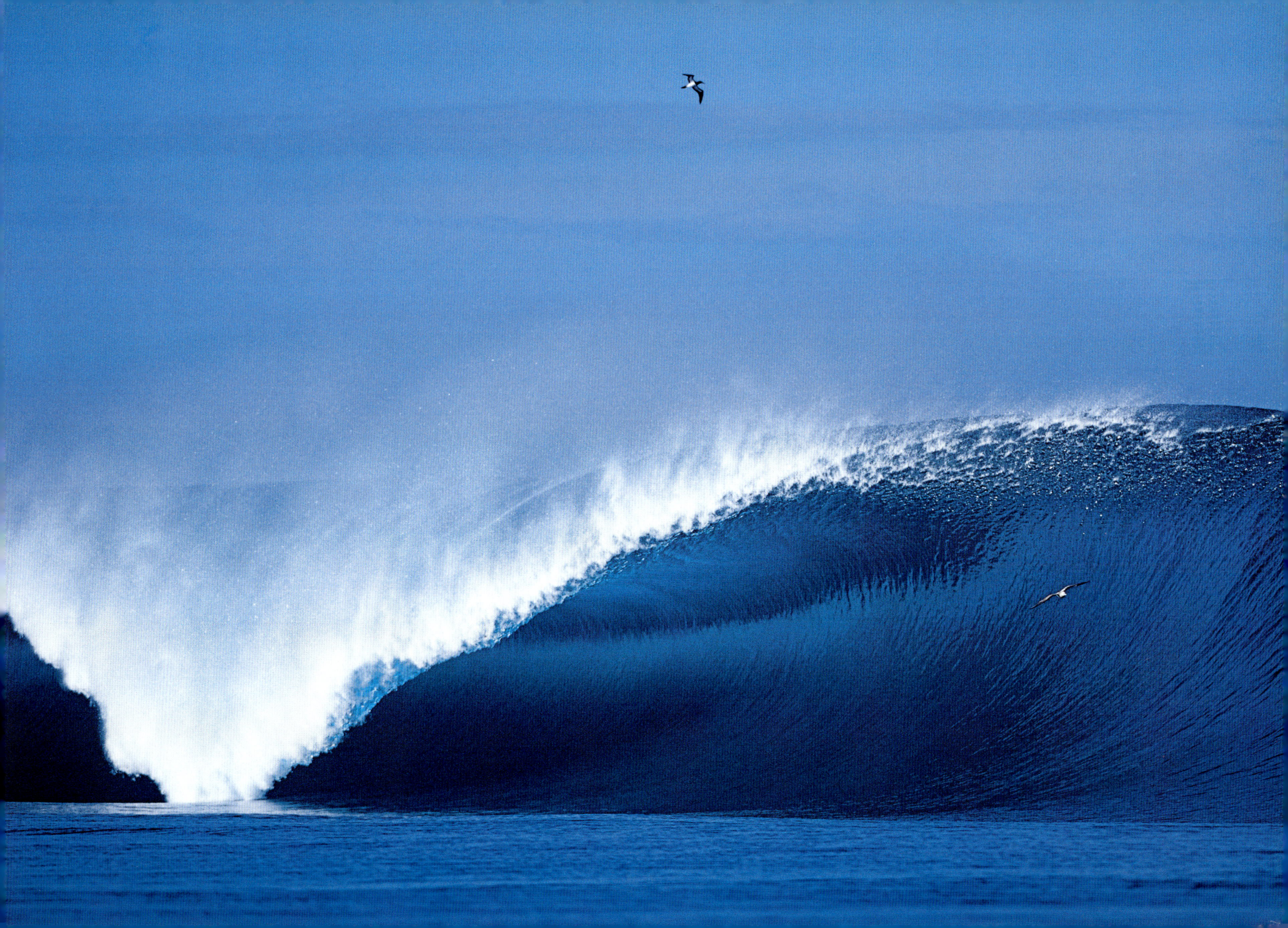

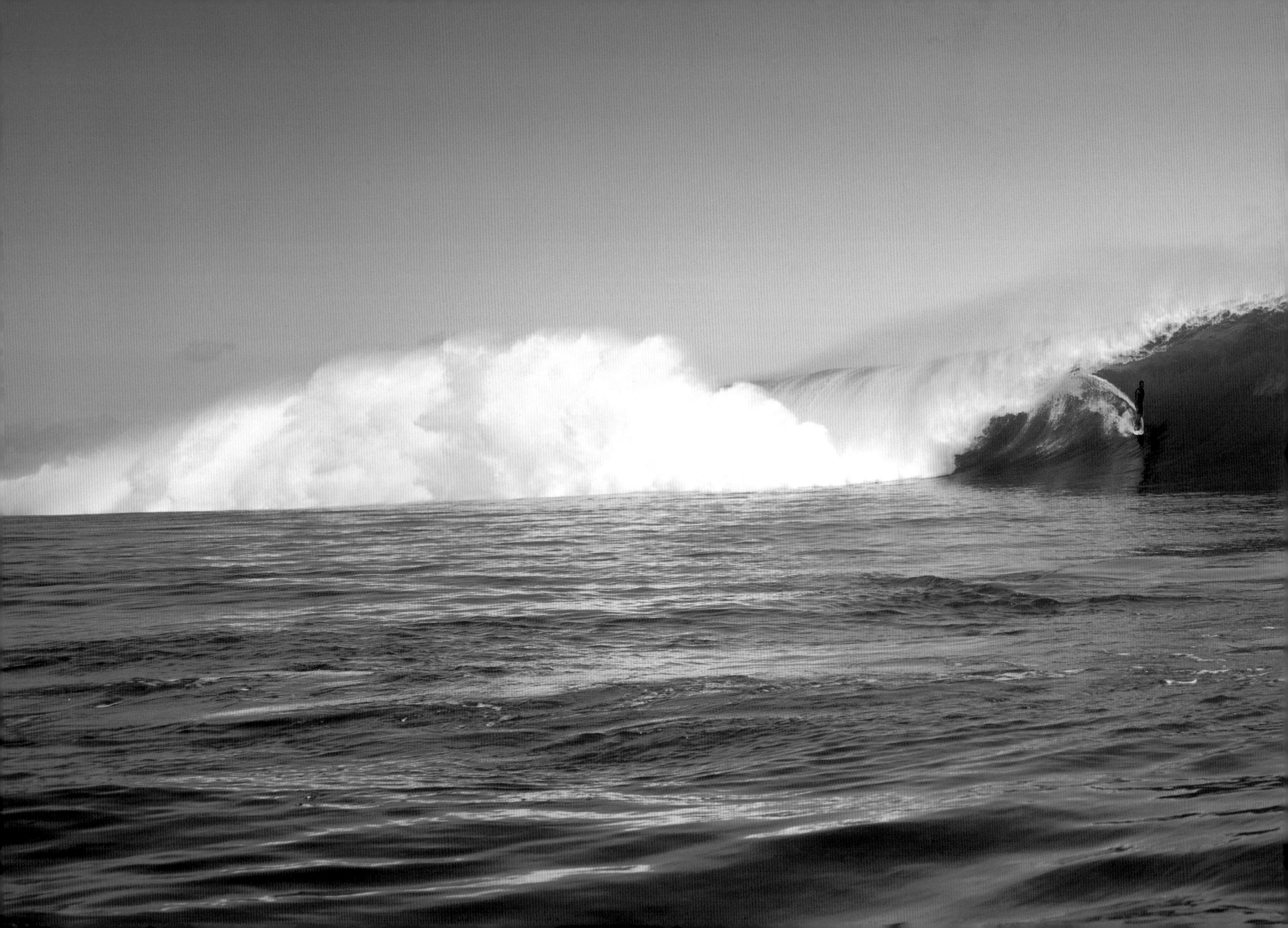

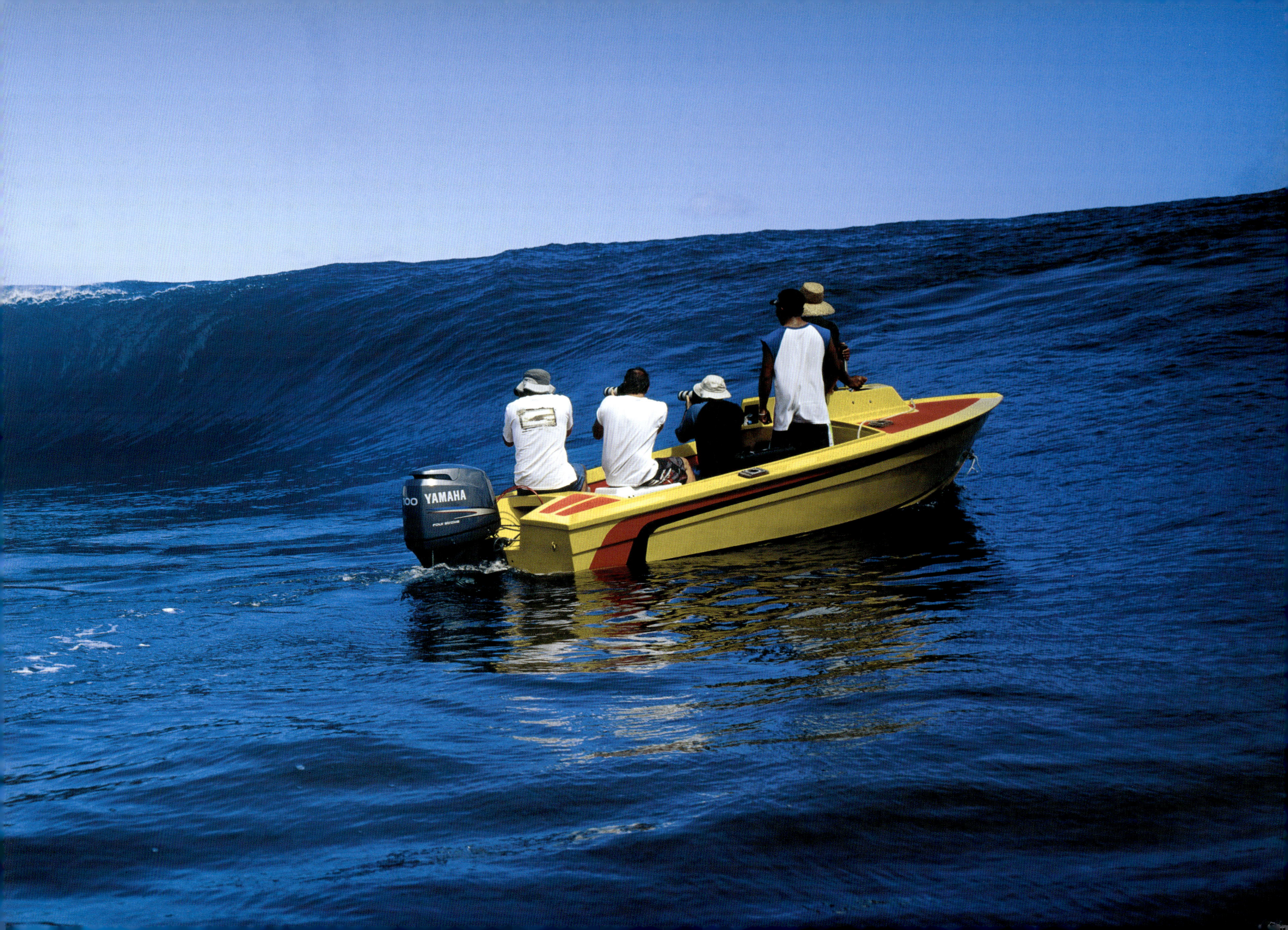

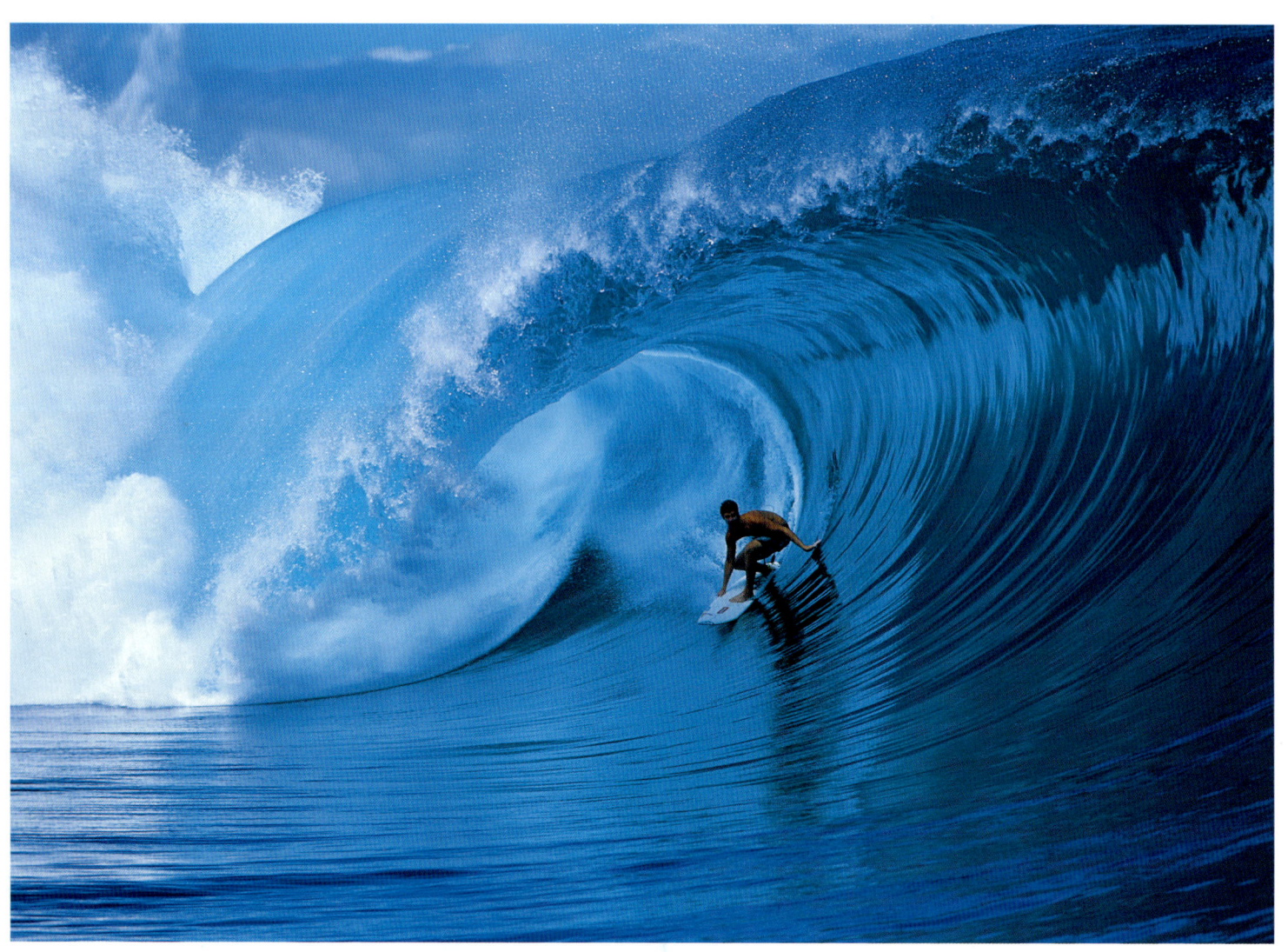

Ian Walsh, 2 May 2005.

Metallic blues, iridescent greens, pale grays or deep blacks: like Pacific Ocean pearls, the colors of the face of a Teahupoo wave reflect infinite shades. The shape and the purity of the tube is a miracle, ephemeral but constantly renewed. It exists so fleetingly that the human eye has no time to analyze this perfect instant as the wave forms, rises, hollows and finally breaks. Only a surfer riding a Teahupoo wave can correctly judge its movement; the onlooker has the impression either of slow motion or of acceleration.

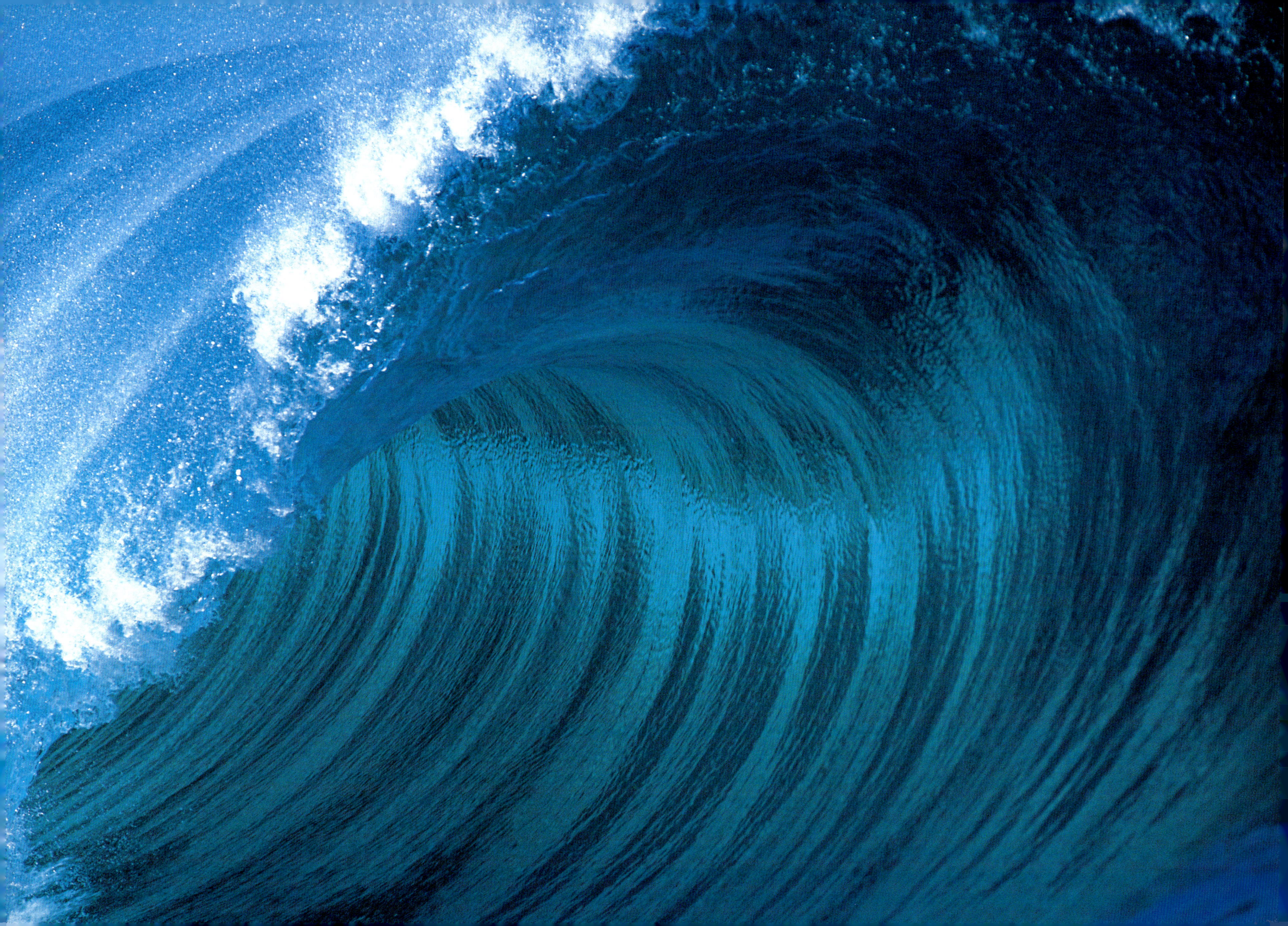

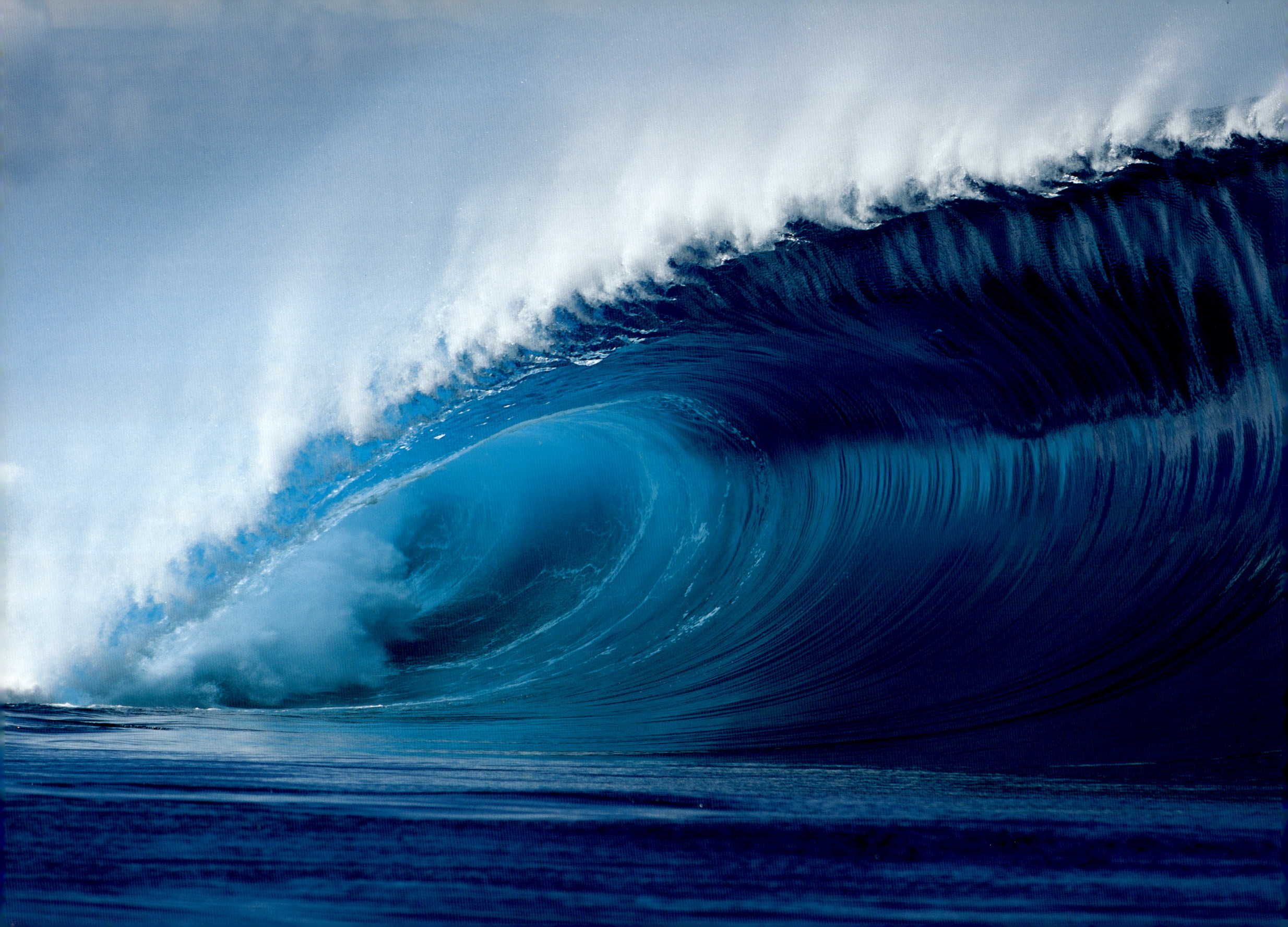

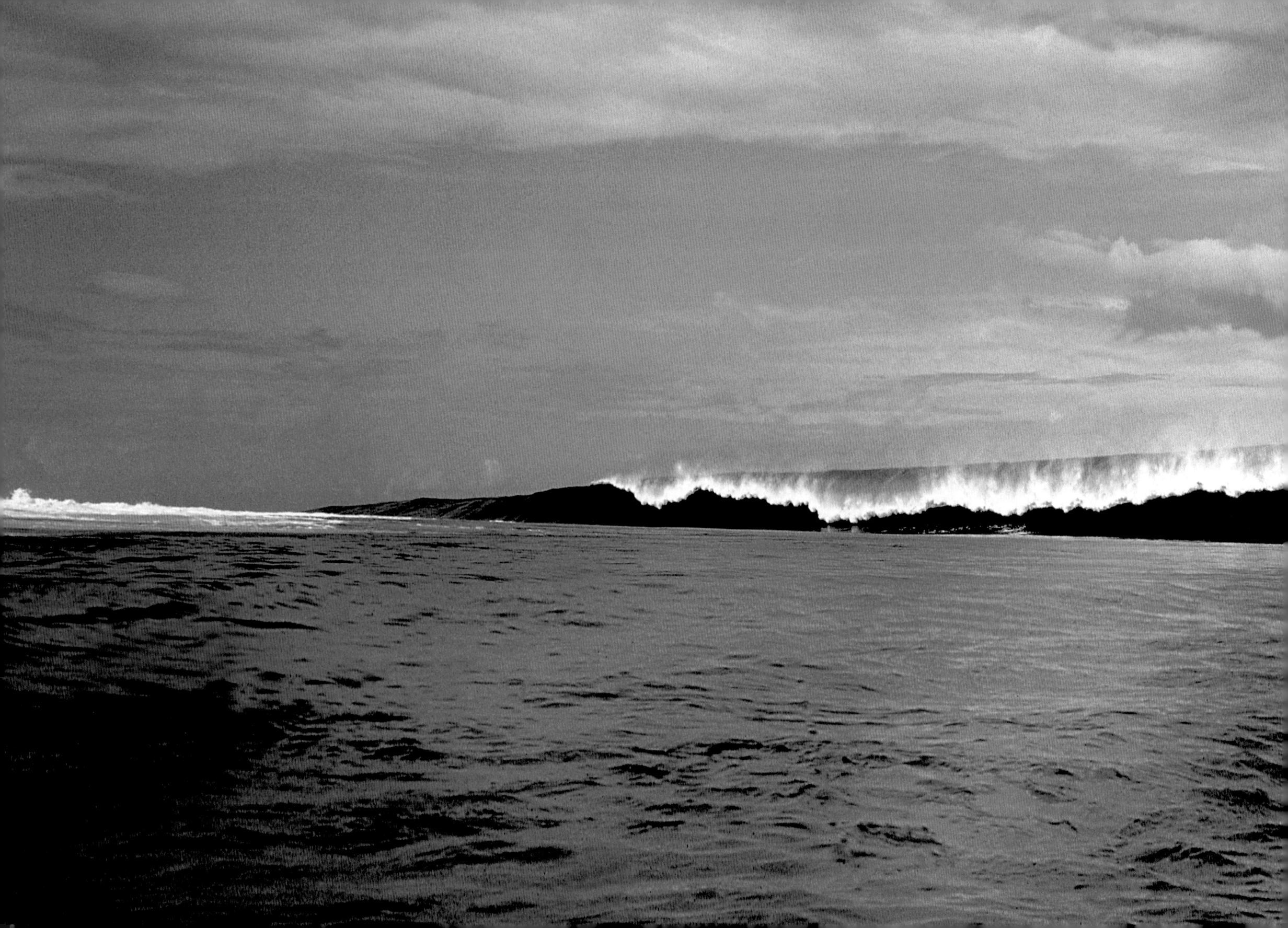

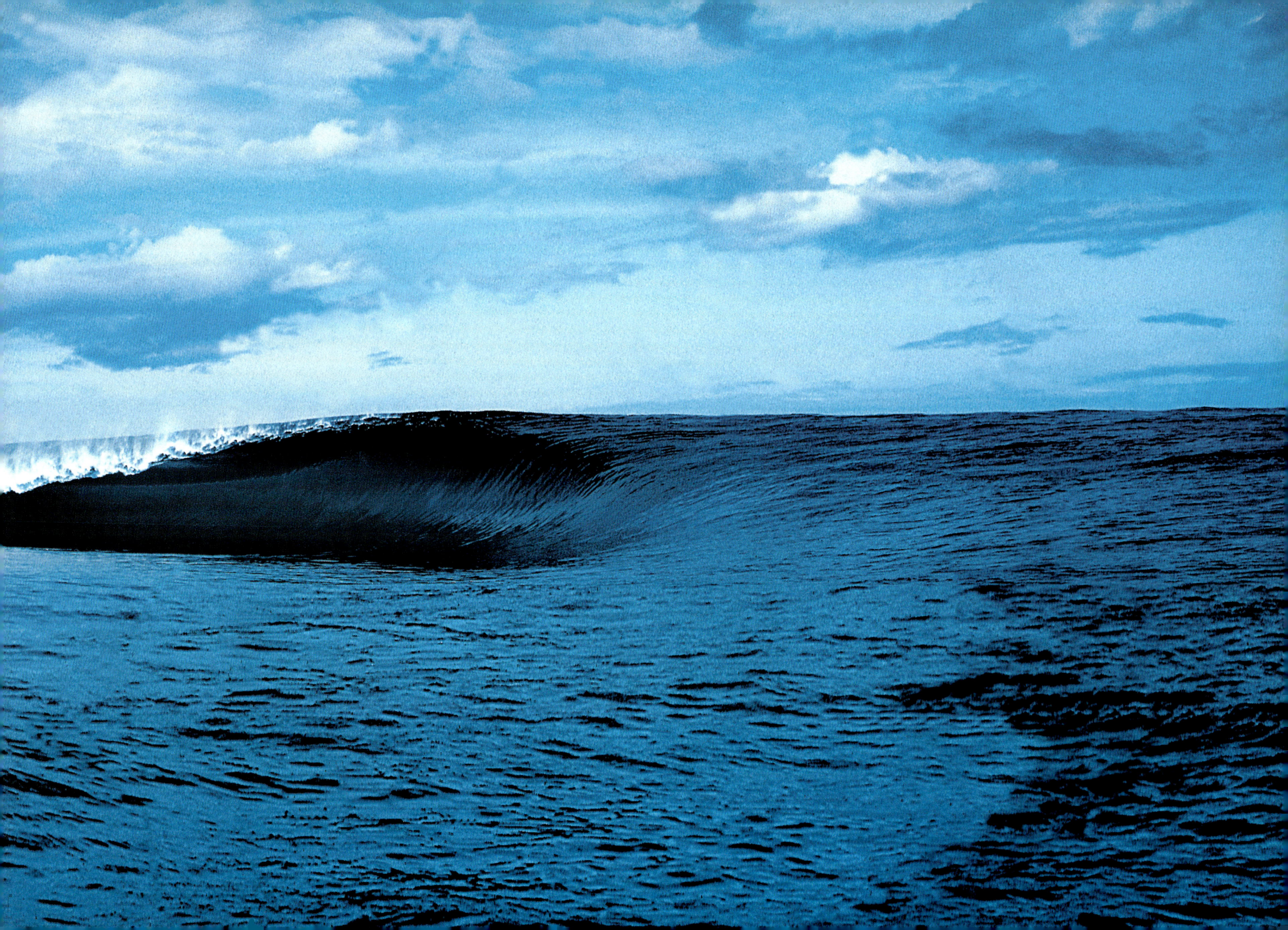

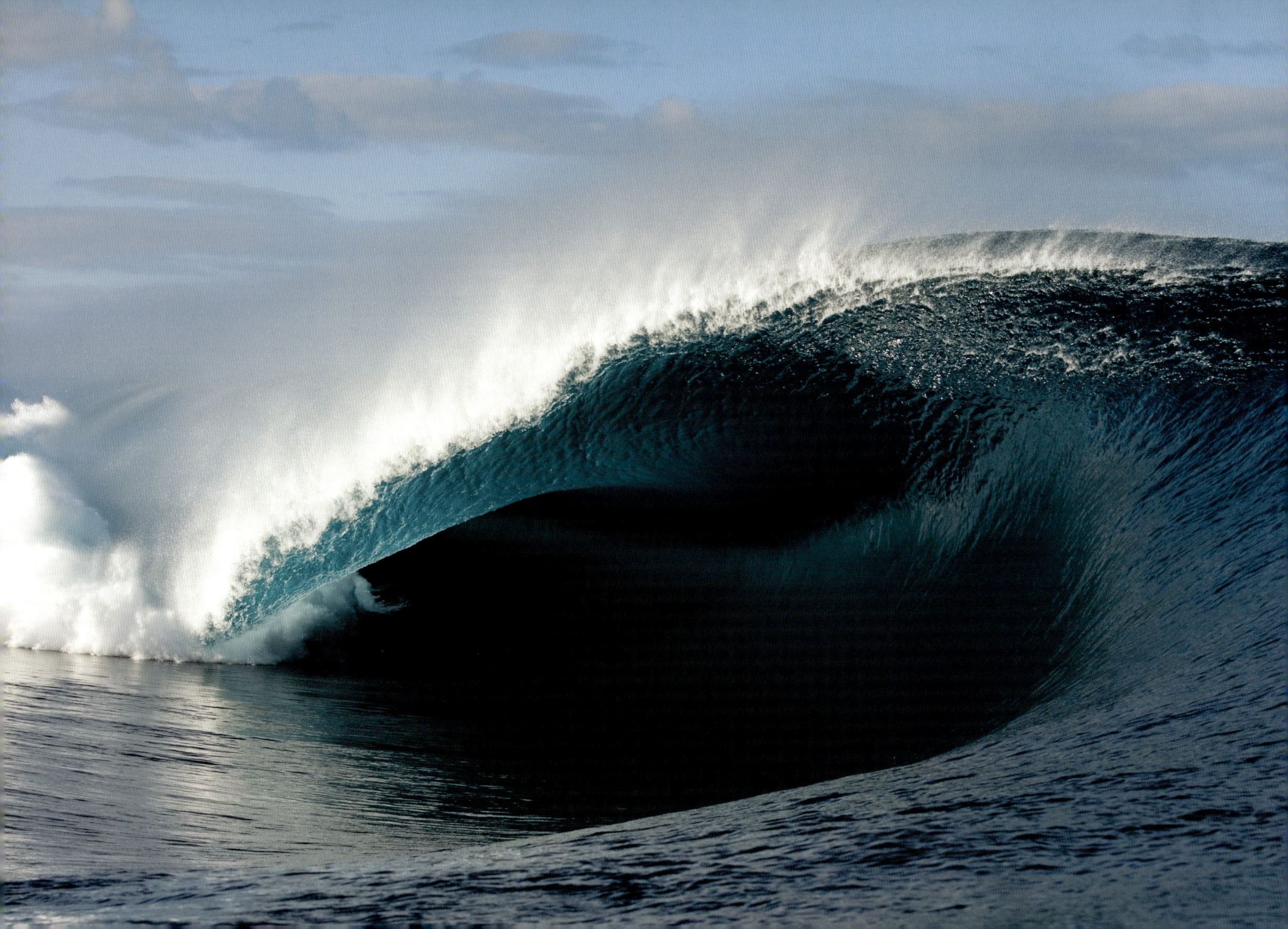

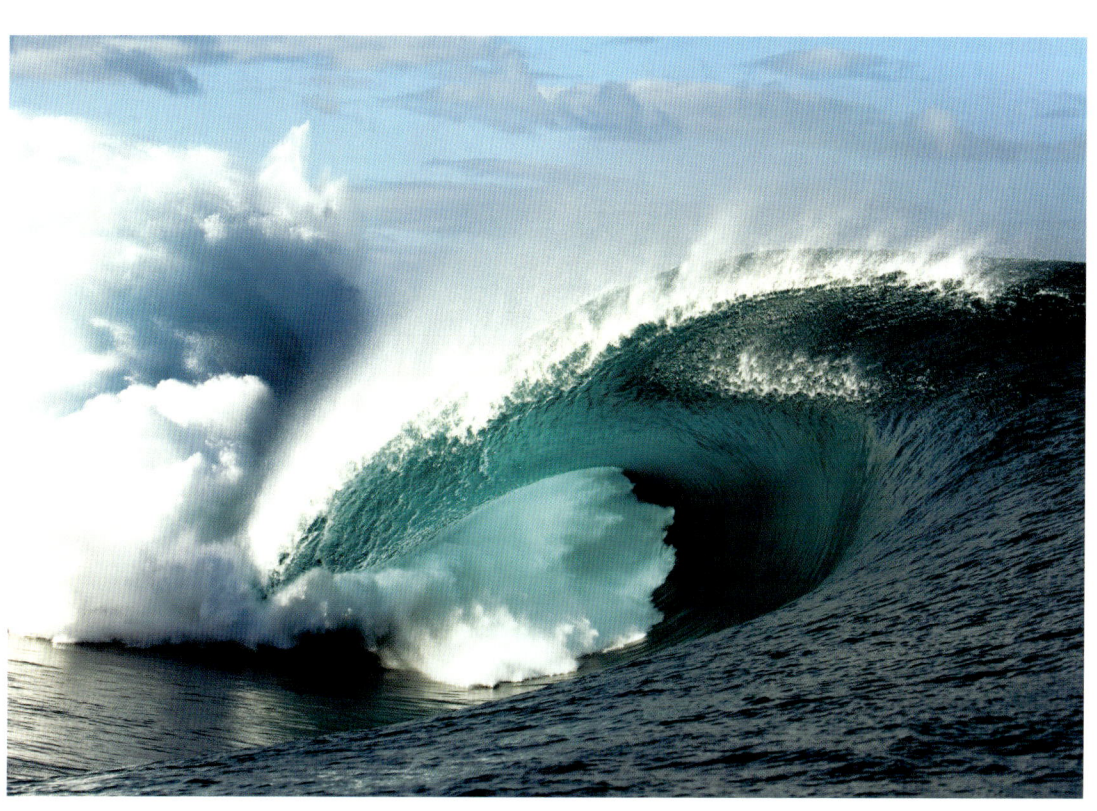 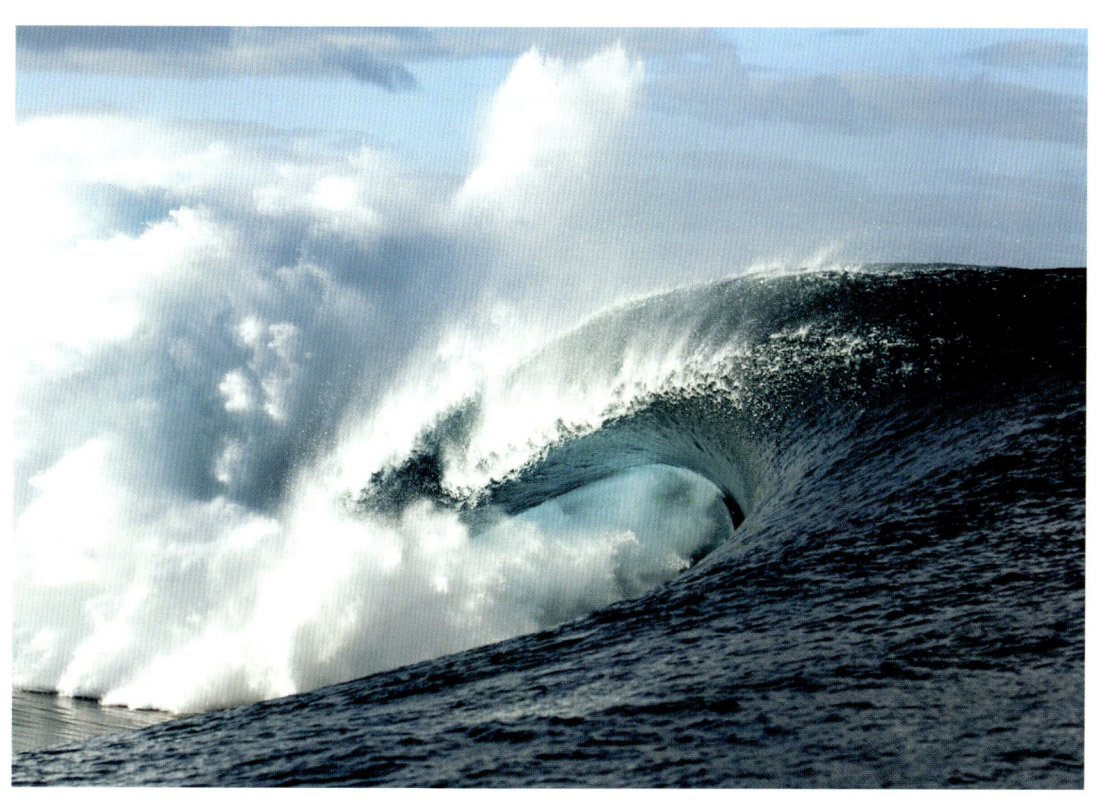

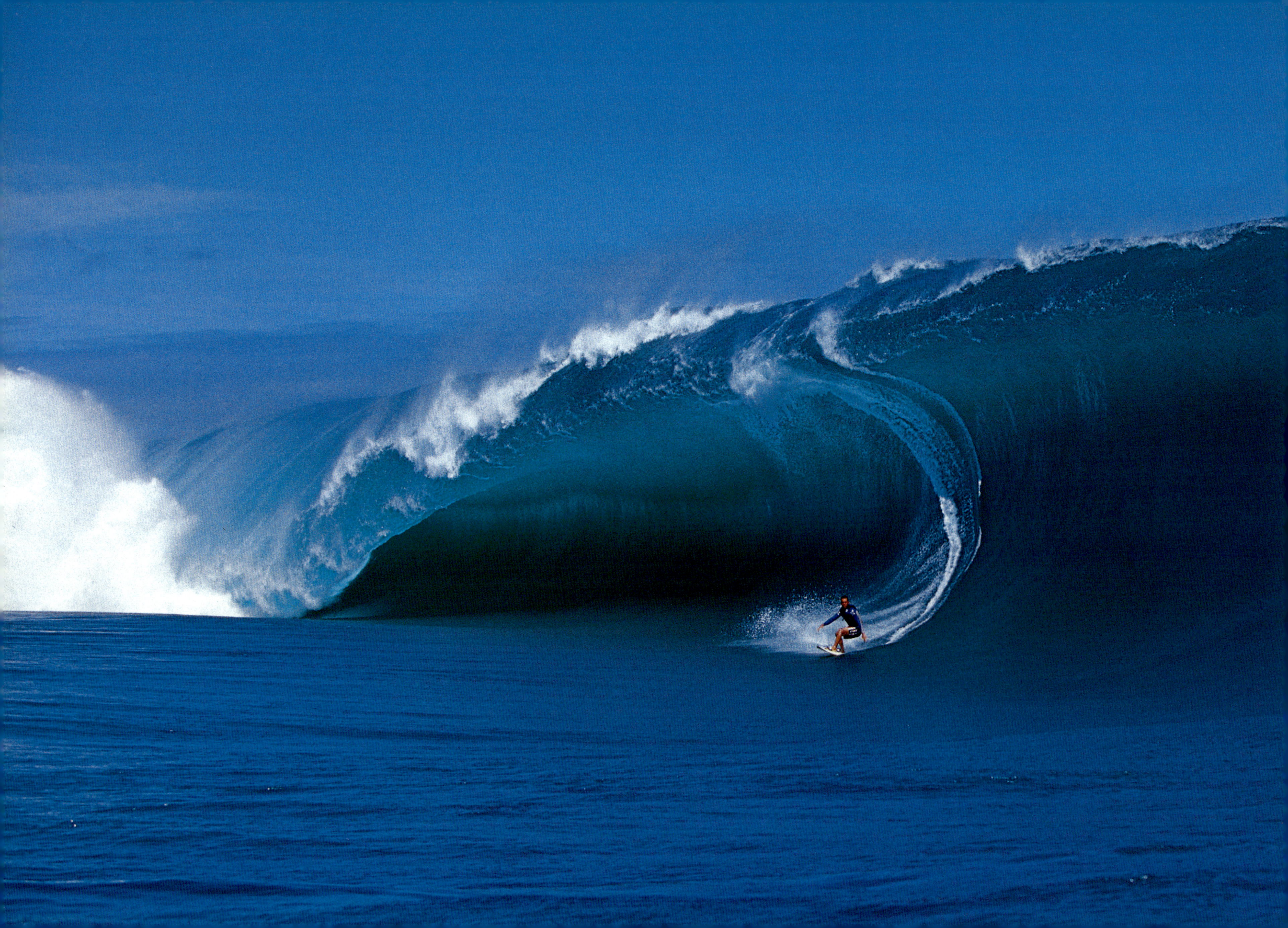

manoa DROLLET

Manoa Drollet encountered perfection at the age of eight while walking with his father at Teahupoo near the southerly tip of the island. They used to spend weekends and holidays with his grandmother who lived in the little fishing village by the same name. The sight of surfers gliding majestically beyond the lagoon on a perfect wave caught their attention. Twenty years later this left would become an icon. This is a primitive scene explaining the surfer's later passion for his sport, "From that day, I was obsessed with the perfection of waves. My destiny was to be forever linked to Teahupoo," recalls Manoa.

Another event was just as seminal. Manoa was fourteen and had never confronted the Wave at the End of the Road, which remained largely inaccessible even to Tahitians. His surfing expeditions on the peninsula were limited to the reefs of Vairao or of Te Hava Iti, otherwise known as "the little channel." On this particular day however, the boat set out for the Hava'e channel. Manoa's first wave at Teahupoo landed him flat on the reef. "It was not a big day – the waves were hardly five feet high. I paddled hard but got locked into the tube. My shorts were torn and my leg and backside were covered in blood. It was certainly a punishment, but it was also a revelation."

Manoa had instinctively grasped the uniqueness of the Teahupoo wave. "Everything was faster, more powerful and more tubular, which placed the wave on a quite different plane. On the line-up, as the wave arrives, you feel the movement of the water as it is sucked back. This mass of water swells the lip which triples in thickness and then drops like a guillotine blade. There are similar waves in Polynesia and elsewhere, but none remain so perfect when they reach a similar size. This is what makes Teahupoo unique. The wave is so powerful that it is almost reassuring, as when one is in a large and powerful car. Since the wave itself is an extraordinary motor, one should rely on its power alone and not so much on a jet-ski."

Manoa's complicated relationship with tow-in derives from the very pure form of surf, more exposed and sacrificial, which he favors.

"The large waves at Teahupoo should really be paddled into. This is where the real pleasure lies. My aim from now on is to surf the waves in this way. In future, this is how historic waves will be surfed at this spot."

Manoa's oft-repeated conviction coincides with his own practice. He seeks to surf the true essence of Teahupoo, confronting one's destiny on the wave, even giving it the advantage, not seeking to cheat and especially not on the wave, positioning oneself

Manoa Drollet: At the foot of the precipice on this historic day for "the Wave At the End of the Road." 1 May 2005

so that Teahupoo either snatches you up or is obliged to let you go.

Manoa's impressive technique gives him the grace of a trapeze artist, a subtle mixture of imbalance and total control. He stands up very early, allowing the fins to slide dangerously under his feet, digging his rail into the face of the wave, maintaining his trajectory in the tube and then slowly relaxing, calm and triumphant in the raging froth of the wave. His inch-perfect curves give an exasperating impression of ease, which is captured in photos of him such as the one on a magazine cover, showing him in a tube, laughing, with his hands behind his head in the ultimate posture of relaxation.

His intuitive approach to the wave and his natural ability make him the surfer most in phase with Teahupoo's perfection. He has grasped its beauty and integrated it into his own surfing aesthetic, not seeking to dominate the wave at all cost, as tow-in *requires*.

"I left high-school just as media attention became focused on Teahupoo. When I began to tow-in, it was in part an attempt to counter the media hype around the wave that was attracting dozens of teams. I had read Jared Diamond's book *Guns, Germs and Steel: The Fate of Human Societies*, which describes how the conquistadores changed the lives of indigenous people on the American continents by introducing disease, weapons, steel and horses. I compared this with what happened in Teahupoo when the conquerors arrived, "armed" and perched on their "mounts." We Tahitians were naked. This was perhaps a necessary stage and it was up to us to respond by setting up local teams. But if tow-in dominates, then the chance to surf fabulous waves by the simple power of one's arms is lost."

This volte-face had been incubating in Manoa for a long time and in which the tragic death of his teammate Malik Joyeux in 2005 played an important part. "Malik and I were enthusiastic about tow-in because we thought in team terms. Now that Malik is gone, nothing can ever be the same again."

Manoa now lives in the village of Teahupoo and intends to build a house a few yards from the lagoon where he had his first revelation. His reputation will doubtless allow him to find a driver to tow him on the biggest days. At all other times, he prefers to surf alone with Teapuhoo, alone with perfection.

'ā'ai

fa'ahiahia

ri'ari'a

tāmata

hanahana

tamari'i 'āi'a

vāhi ha'utira'a

mana

Fear

This is a story told by veterans of the Teahupoo line-up. In his first session at the break, a young rookie on the World Championship Tour (WCT) could not find a take-off position under the lip. A local came up and said: "This used to happen to me but one day a healer prescribed me some infallible pills. I took them and from that day on, I was able to get into position without a problem." The young professional, surprised and suspicious, asked what these pills were. "Arihua (balls)," was the reply.

This is of course just an image. Numerous great ladies of surf, such as Queen Keala Kennely, have proved that courage is not only a male attribute. However, it is clear that a person who puts his or her life at risk above the reef must possess something setting them apart from common mortals. One could call it guts, those inglorious organs which surfers hide behind their toned abdominals but whose noisy, anguished complaints torture them from dawn and increase as the moment of confrontation with the wave approaches.

Courage consists in dominating fear, not lacking fear. One can wonder at beauty and perfection but in the face of danger one must act. Every ounce of your being incites you to make a choice: paddle out to sea to confront the monster heroically, stay on the boat or flee to the mountains and meditate on the power of the ocean and the respect due to it.

Fear is an emotion that allows us to adapt to extreme situations by organizing our reactions and survival instinct. Stress provokes a physical and chemical reaction, which prepares us for combat – or retreat. In the first case, the adrenalin secreted by the nervous system spreads through the blood, the heart beats more strongly and the muscles store energy necessary for dealing with imminent danger. In a split second, fear paralyses instead of galvanizing. Hands and legs begin to shake uncontrollably and the face becomes pale and drawn. Fear has won the battle.

Courage is the counterpart of fear. A person without fear cannot be considered courageous. Teahupoo is just the pretext for the real battle, a particularly captivating one, in which a man struggles with himself, seeking to conquer his mortal fears.

On such a wave, the more you tremble, the more risks you have to take while remaining in control of events rather than simply undergoing them. It is especially important not to be influenced by the shouts of the spectators in the channel since it is never clear whether they are shouting, "*Go oooo*" or "*No oooo*."

Doubt is the malevolent companion of fear, breaking the surfer's concentration and affecting his judgment and decisions. "At Teahupoo, the slightest hesitation at take-off will send you straight to the bottom," declares Damian Hobgood, who suffered a severe injury to his shoulder at the spot. "You must not, even for a fraction of a second, think of failure, otherwise it is all over. And once you have made the drop, another sort of fear awaits you, a fear which can take complete control of you."

Teahupoo has set new standards in surfing because it inspires fear not only in all who confront it but also in those who contemplate its sublime fury. The spectacle of its power is captivating, as in the case of a Grand Prix race, a downhill ski run or a trapeze act, when a somewhat morbid excitation is created by the possibility of a spectacular, or even mortal, accident. When a surfer positions himself correctly, as does our young rookie "with his balls well attached," every single spectator shivers along with him. Teahupoo is a High Mass, offering a sort of Communion in fear to the whole surfing community.

Strider Wasilewski. 29 April 2003
This wave had several lips but only a few square feet of surfable face. "As I reached the bowl, I could see that the reef was completely dry. Then the wave turned on itself, forming a right angle and immediately shut down as it met the right coming from the channel. There was no possible escape. I hit the face at full speed and the wave swept me as far as the lagoon. I survived, but only just.

Hira Teriinatoofa. 4 July 2001
Surfing Teahupoo is an art which requires the artist to risk his life. The quality of the spectacle depends on the courage and commitment of the warriors who confront the monster. Here Hira Teriinatoofa is happy to have reached the safety of the shoulder and to be emerging unscathed from the eye of the cyclone.

Votea David, alongside surfer here seen on the roof of the world, torn between fear and extending the limits of human achievement.

Tahiti Pro 2000. The Brazilian Neco Padaratz suffers a wipe-out and is flung to the bottom in a near-death experience, one step from the gates of heaven: "I felt my strength seep away. My lungs were burning. I begged God not to let me die. The waves were breaking above me and everything was black." Rescued by the water patrol, he survived but has never returned to Teahupoo. Renunciation is sometimes proof of another kind of courage.

Duane Desoto's terrifying wipe-out in August 2000. The price paid by the Hawaiian was a board broken into three pieces and a nasty knee injury.

garrett McNAMARA

Every man must sooner or later confront his deepest fears. Once he has done this, fear no longer has a hold over him. This method, which is also that of the samurai, is the one chosen by the Hawaiian Garrett McNamara when shaping up to the planet's most dangerous waves. "If it can't kill you, it ain't extreme" is for this modern surf-warrior more than a mere slogan – it is a profession of faith. Garrett has built his whole career on his extraordinary courage and the importance that he attaches to the status of big-wave rider. To the internaut watching him fearlessly confronting 60 ft (18 m) waves, this surfer seems to recognize no limits and feel no fear.

"We all feel fear," he admits. "We just have to conquer and disguise it."

But how? With the head, the heart, the soul – and ambition.

This last quality Garrett McNamara possesses in abundance. In the emerging tow-in scene of the 1990s, his spectacular triumphs made him a respected specialist. His exploits often took place at Jaws where he won the Tow-in World Cup in 2003 by surviving a now-legendary tube, as big as a cathedral. As a waterman in the purest Hawaiian tradition, he had served a laborious apprenticeship at Waimea, Sunset and Pipeline and still trains hard, paddling along the Hawaiian coastline or carrying stones under water while awaiting the ultimate wave.

On 11 September 2005, McNamara arrived at Faa'a Airport in Papeete from Florida to confront the largest southern swell for ten years, "I realized that something big was going to happen at Teahupoo. I had never surfed such a direct southern swell and I knew what this would involve: gigantic barrels unfolding endlessly along the reef, but without the threat of a western bowl ready to nail you."

On the way down the peninsula to Teahupoo, the lagoons were in frenzy, flinging spray and foam into the gardens and across the roads. The conditions

were violent and uncontrollable. "When you get out to sea on a day like this, your fears completely dominate you, as the Brobdingnagians did Gulliver, but as soon as a wave arrives, fear disappears and an incredible mental agility takes over, giving you the right reflexes and intuitions. You are no longer the prey but the hunter."

Garrett was not alone in wanting to surf this swell. Numerous other teams were champing at the bit in the Hava'e channel. "The situation was not out of control but at that time Jaws had given tow-in a bad name with sometimes more than ten teams going after the same wave. To have such a crowd at Teahupoo was new and this was why the wave that I shared with Malik had such an impact."

Of the seven waves surfed by Garrett that day, only one has passed down to posterity, a giant double tube surfed with Malik Joyeux.

"The wave that I shared with Malik provided me with the most beautiful sight of my life. As I prepared to take off, I could see his face in three-quarter profile and his intense concentration made me want to remain deep so that I could keep watching him. Above Malik's head, I could see the bluest and most beautiful lip on earth curling over on itself, forming a tunnel leading in the direction of the boats in the channel. It was fantastic, more powerful than anything that I had ever experienced. When the wave exploded, I overtook him and it was only then that he realized that I was behind him. I grabbed his hand and kissed it three times. I wanted us to celebrate together this new sport whose ambassadors we had become. Going after the wave of a lifetime is a very personal quest and it is not every day that you can surf with a friend a wave capable of killing."

In spite of his will to win, Garrett never forgets that survival is the main concern. Five years earlier, during a much less violent session, he had seen a wave from hell crush the life out of local boy Brice Taerea, Teahupoo's first victim. Trapped inside the lagoon, the surfer tried a duck-dive but the wave up-ended him and raked him along the reef, leaving him no chance.

"Brice suffered the worst injuries that I have ever seen. His body was mangled by the reef. He was unconscious and bleeding from the nose and mouth. I also had cuts and my blood mingled with his in the water of the lagoon. I tried to keep him alive but he died several days later. I will never forget that day. Whenever I surf here, his spirit is always with me. I think of him and of Malik and fear has no further hold over me."

a bird's eye view

Keala Kennely, several times winner of the WCT event, as she became the first woman to be towed in at Teahupoo. May 2005.

'ā'ai

fa'ahiahia

ri'ari'a

tāmata

hanahana

tamari'i 'āi'a

vāhi ha'utira'a

mana

The Challenge

Teahupoo was at full throttle with its angry lip furiously discharging tons of water. In the Hava'e channel, there was a joyful riot of color created by the spectators in the outriggers and the fishing *potimarara* tied up to a line of white buoys, all savoring the exceptional conditions. The smell of engine oil mixed with the tang of the ocean. The scaffolding constructed in the lagoon to house the judges was silhouetted against the unnaturally green hillside of Taiarapu. The sets arrived in pairs, or in threes at the most, high, square and threatening. Every quarter of an hour, a monster rose up from the depths and exploded onto the reef with the power of a tornado. There before us, yet again, was quite simply a "classic Teahupoo."

We were not the only ones privileged to be present on the last day of the trials of the Tahiti Pro 2000, the fourth of an already legendary competition. For the first time, a co-sponsor of the contest was broadcasting the event live and globally via the Internet. The performances were worthy of the technical exploit. Andy Irons gave an encyclopedic review of surfing technique in a sea whose dark waters seemed to reach out toward the sky. In the qualification finals, with his back to the monster and gritting his teeth, the Hawaiian surfed four half-hour heats in a state of grace, outclassing Kelly Slater who, however, ultimately won the contest!

Professional surfing had entered a new century, abruptly and without a backward glance. Everyone realized that Teahupoo was going to occupy an important place in the history of surf and that it would be the center of media attention as had no other wave before. Its almost archetypal aesthetic qualities, the surreal size of its tubes, the constant threat of the coral carpet hidden under its belly, the hypnotic angles offered to the web cam, all of this meant that Teahupoo had come to represent the supreme challenge, capable of sending the crowd hysterical and reinventing surf without betraying its legend or its authenticity.

Great challenges require great men. Only an exceptional destiny can lead a champion to push back the limits of his sport in the endeavor to surf the unsurfable. Greg Noll recounts how, in the sixties, his band used to contemplate Banzai Pipeline, wondering whether one day they would be able to surf the brute on a board. Phil Edwards was the first to meet the challenge posed by nature to man's courage and intelligence. In the following years, the Hawaiian and world elite paid a heavy tribute to this exceptional challenge in glorious wounds and even tragic deaths. Then came Gerry Lopez, a genius with the karma of a prophet, and everything seemed so easy. Under the Master's boards, always decorated with his trademark lightning bolts, the unconquerable monster became a Zen temple full of harmonious exploits. For thirty years, Pipeline was to reign unchallenged over high-performance surfing. As the most prestigious wave on the circuit, Pipeline had the power to make and break careers and each winter it created its own legend of resounding exploits, dramas, revenges and triumphs.

Like Pipeline, Teahupoo draws much of its legitimacy from the extreme simplicity of the few fundamental principles required to surf it: a committed vertical drop followed by a smooth line placing the surfer in orbit in the tube for several seconds before the unbearable climax. Like Pipeline, Teahupoo has passed from the status of an unsurfable wave to that of an unavoidable challenge for surfing geniuses at the height of their powers.

There is however one major difference between these two liquid monuments: no one has ever seen Teahupoo close-out. The quest for the most extreme and violent wave in the world thus ends here, at the end of the road.

Teahupoo is a tiny, friendly village set in a colorful and leafy paradise. Languid-leaved banana trees, startlingly red hibiscus and white, heavily scented *tiaré* flowers provide the décor. At the foot of the green velvet mountains of the Tahiti peninsula, sparkling-eyed children romp along the riverbanks or on the beaches of black sand, weaving in and out of clapped-out pick-up trucks. At the entrance to the village, a red and white milestone carrying the number 0 succinctly announces the end of the road. In the evening, when the sky is closing in, sensuous golden rays flood the hillside in a final blaze of glory. Several hundred feet offshore, beyond the sparkling lagoon, the coral reef traces a line on the expanse of still dark water with its angry white foam.

Life flows by here at the leisurely pace of the mountain waterfalls. Tahitian faces are open and gestures restrained. A contagious smile is obligatory. Everything in Teahupoo is calm, friendly and peaceful. Everything that is, except the reef where the waves break with extreme violence and primitive beauty. Before becoming a surfing Mecca, the wave of the freak Hava'e channel has always been recognized as one of nature's miracles. The fresh water that has flowed down from the extinct Taiarapu volcano for hundreds of thousands of years has prevented coral from forming over a large part of the lagoon. It is as if the giant axe of a warrior god split open the reef at this point. This unevenness in the ocean floor causes a dramatic change in the level of the sea, which passes abruptly from 165 ft (50 m) to 3 ft (1 m) in depth. During the dry season between April and October, the southerly and southwest swells generated by the Roaring Forties fling themselves onto these razor-sharp coral blades. On impact, a part of the wave is held back by the reef while the portion coming from the ocean depths retains its initial speed. These two forces clash, pile up onto one another, forming a wall that presents a single deformed face. A wave that is as high as it is broad sucks the water from the reef in front of it and forms a tube of gigantic proportions.

Because of the isolated nature of the site, no one knows who was the first madman to entertain the idea of surfing this wave. Surf historians are lost in speculation as to the precise moment when man first ventured onto this new planet. It is generally thought that the first recent surfers at the Hava'e channel were Tahitians who, in the early 1980s, on their way to surf the channels of Vairao, Te Ava Iti or Te Ava Ino, ventured in their fishing boats out as far as the isolated Teahupoo reef. Among these pioneers, a special place in history belongs to the first Taiarapu locals, the Fairare brothers, known respectively as "Camion" and "Camionette" ("Pick-up" and "Little Pick-up"), since the tubes that they surfed could easily have contained such vehicles.

In 1986, bodyboard stars Mike Stewart and Ben Severson surfed the first session recorded in serious conditions at Teahupoo. In July 1994, *Surfing Magazine* in its *Special Photo* edition published the first Teahupoo cover in history, a sequence surfed by the Hawaiian Erik Barton. Since then there have been more than 300 covers worldwide. From the mid-1990s, the Spot at the End of the Road – sometimes known as "Kumbaya" – has attracted increasing

attention from surfers on photographic trips. In 1996, Kelly Slater and Tom Carroll made a film in Tahiti, reveling in the crystalline waves of a Teahupoo in a more civilized mood.

All who surfed Teahupoo in the first ten years, from 1986 to 1996, now agree that they had no idea of the wave's real potential. This has only been revealed by the world's best surfers competing regularly against each other at the spot. In 1997, a French entrepreneur, Jean-Christophe Clénet, and the Tahitian Surf Federation organized a World Qualifying Series (WQS) competition at Teahupoo, entitled the Black Pearl Horue Pro. The waves on that occasion reached no more than five feet but one set did manage to throw on to the reef the huge *Aremiti* ferry hired to accommodate the judges and officials. Andy Irons, who was totally unknown at the time, won this first competition. A year later, the brutality of Teahupoo exploded under the eyes of the world.

All hell was unleashed by a diabolical southwesterly swell. The waves were monstrous and sometimes totally unsurfable. On the biggest day, when everyone thought that the competition would be postponed, the organizers decided nevertheless to throw the gladiators into the arena. There were 48 surfers left in the competition but only half of them surfed that day, the rest being terrorized by the price to pay if they fell. Within a few hours, Teahupoo had devoured ten boards and upended jet-skis, photographic material and even the judges' tower. The pro circuit crew, even though not unaccustomed to rough weather, was in a state of shock. In their articles, journalists used terms like "war" and praised the courage and heroism of the surfers with a wealth of superlatives. The surfing world was in total effervescence and the editors fought for the images, convinced that they had found the Wave of the Third Millennium.

Kobby Abberton won the competition with Conan Hayes coming second.

"I was seventeen at the time and I knew that I could win because I wasn't frightened of dying and there were not many of us like that," recalls the Australian. "I remember that those who took the plunge were aware that they were doing something exceptional.

Tahiti Pro 2000. Kelly Slater comes out of retirement to confront his exceptional backside technique to the challenge of Teahupoo ... and wins the contest. *Veni, vidi, vici.*

We all pushed ourselves to our limits and helped to reveal one of the world's most beautiful waves."

From then on, it became impossible for the major circuit of the world championship to ignore the impact of such a wave. In 1999, the Gotcha Tahiti Pro became part of the World Championship Tour (WCT) and the world elite was forced to confront this wall of water. The conditions were again spectacular and most of the Top 44, who had never surfed the spot before, had cold shivers when they first saw the Monster. In the first round, Cory Lopez took off on a bomb that remains the craziest and most violent in the history of surf. He had only one chance in a hundred of surviving the drop since his strokes were no match for the suction of the wave. However he succeeded in slipping his board under his feet and plunged into the unknown. A second later everything fell apart around him. For an instant, it seemed that he had made it and surfed the unsurfable. However the tube swallowed him up pitilessly as the crowd gasped in horror and admiration. Thanks to a more judicious choice of waves, Mark Occhilupo carried off the final. This victory was to play a crucial role in his heroic conquest of the world title and his impressive return to top-level surf, fifteen years after his début.

"Several seconds after my victory, I had tropical rain running down my face and a rainbow lit the sky. I have never felt anything like it. I was happy to have won, but especially to be still alive. During that week, I had

Shane Powell on THE wave of the 2002 edition.

rung my wife every evening saying that somebody was certain to die at the spot."

Occy was right. The great Teahupoo party would never be the same again. The 2000 edition was marred by the tragic death of Brice Taerea during a session a few days before the start of the competition. Kelly Slater chose to come out of retirement to take part in the competition that was dedicated to the memory of Teahupoo's first victim and to measure his own legend against that of the Teahupoo phenomenon. On the biggest day, in the qualification finals, he was up against Andy Irons. He would be in constant contention with Andy for world titles over the following seasons. This was the beginning of one of the greatest sporting rivalries of the new century and of the spectacular show now known as the Dream Tour.

Although beaten by Andy in the trials, Kelly won the competition in worsening conditions by performing vertical re-entries that no one had ever before attempted. With Kelly and Andy, backside surfing had come to power at Teahupoo. Slater won again in 2003, despite a broken foot, and in 2005 he took the final in a perfect heat with two waves each marked ten, a first in the history of the Association of Surfing Professionals (ASP). Andy Irons won the Tahiti Billabong Pro in 2002 in frenzied conditions that allowed him to display his supremacy at the spot. However, some of the most gifted goofy-footers, such as Cory Lopez, winner in 2001, CJ Hobgood in 2004 and Bobby Martinez in 2006 have managed to challenge the supremacy of the Teahupoo backside aristocracy.

Ten years after the first professional competition in Tahiti, the Billabong Pro is now the principal competition on the tour and the No 1 challenge in high-performance surfing. However, since a certain day in August 2000 and an otherworldly wave that Laird Hamilton surfed by tow-in, a competition of a new kind is raging around the Hava'e channel, pitting the craziest big-wave riders against mutant waves on which even the leaders of the Top 44 would have no chance of survival.

In spite of a broken left foot, Kelly Slater wins another championship title and contemplates his prestigious reflection in the mirror of the lip. Teahupoo 2003.

The French Touch, Didier Piter 1999

Pancho Sullivan buries his head in his hands: the wave of his life, or of his career, passes him by. In any case it was a 10-out-of-10 wave.

A rare angle taken from the reef, showing the perfection of Corey Lopez's trajectory.

kelly SLATER

Elvis Presley once said, "What's wrong with challenges? They keep you young."
For Kelly Slater, unanimously recognized as the King of Surf, Teahupoo personifies a challenge and offers a second youth or at least a second career.

At the end of the 1998 season, after six victories in the world championship, Kelly withdrew from the professional circuit. Thus the following year, when Teahupoo became part of the WCT circuit, the King was absent. "I was always telling the press that I had no intention of returning to the World Tour, that my new life as a free surfer was tremendous and that I could live without the adrenalin rush of competitions. But in fact, I had seen the photos and all I really wanted was to surf Teahupoo and to win this event."

Next season, at the Tahiti Pro 2000, he was offered a wild card and surfed a curtain raiser on the biggest day of the week. "I came second to Andy Irons in the trials but I won the event. After that, I won nothing for the next three years. When I returned to the circuit in 2003 I won my first victory at Teahupoo even though I had broken my left foot. You could say that it was this wave that restored my will to win because it was a perfect tube and it raised the level of the surfing and the championship. I wanted to measure myself against this incredible left which was the proof that competitive surf could still offer new challenges."

Surfers, who are mostly intuitive beings, have a very physical perception of their art, allowing their bodies to express themselves through very precise movements uncontaminated by too much cold reflection. In Kelly Slater's case, surfing at Teahupoo consists in a theatrical presentation of his detachment and stoicism in the face of the elements. When he takes off on a wave, all idea of combat and all trace of a struggle disappear. There is room only for perfect harmony and the exhilaration that comes with it. Slater then produces a surf, which resembles slow-motion space walking, full of loose curves and razor-sharp trajectories.

On 19 May 2006, alone in the water for the final after his friend Damian Hobgood was injured, he won his third Tahitian victory and, for the first time since the WCT heats have been judged on the best two waves, he scored a perfect 20 out of 20. For Kelly, who was known for smashing records and pulverizing statistics and who had won every conceivable competition, challenges were rare at this stage of his career. This exploit gave him his seventh world title, seven years after his first.

"To score two ten-point rides had long been one of my aims and to achieve it in the final of the most important competition was the culmination of my career. This was something very intimate and unique, not for the sake of statistics or history – it was just a very personal accomplishment. This moment was not happier or more perfect than my

other world titles or my victories at Pipeline or on other waves that command respect. It simply gave a greater feeling of fulfillment. My career could have finished there and I would have had the impression of having achieved that for which I was born. Without Teahupoo and the two tens that it offered me as we were alone together, I would perhaps never have known such a moment of perfect fulfillment."

Having won the two main big-wave events, the Eddie Aikau at Waimea and the Mavericks Surf Contest, California, Kelly is a respected big-wave rider but 0has also excelled at Jaws and at Cloudbreak during the 2005 Perfect Storm. However very few free-surf images of him at Teahupoo exist, and actually none towing-in. "It is probably just destiny but I have never been there for one of the major swells that have punctuated the history of the wave. I would love to take part in one of these mythical tow-in sessions of course but I am not sure to want it as much as Shane Dorian did, for example. There are roughly twenty specialists who are currently capable of surfing such waves, which is a lot. And some of these surfers such as Manoa, Shane or Poto have each tamed more than twenty of these monsters. After Brice Taerea's death, we thought that any wave of more than twelve foot would kill us. But since then, surfers have survived terrifying wipe-outs and pushed back the frontiers of fear. This is why I like to do paddle-in competition surf at Teahupoo, because fear and the desire to win are inseparably linked to pleasure."

andy IRONS

Any art, no matter how much in harmony with everyday life, must be based on a project, a certain expertise and a philosophy. The art of surfing Teahupoo requires that to these be added courage. Surfers can be classified in function of varying degrees of four qualities – courage, technique, style and ambition. These constitute a surfer's personality and thus his style.

The basic principle is that a surfer who wants to mark his generation must possess an assortment of these four qualities. He also depends on external circumstances such as luck in the wave lottery, the support of his team, the press and the public, his impact on the media, his charisma, etc. The ideal is, as with Andy Irons, to possess all of these qualities to the highest degree if one wishes to become a great champion. At least half of these qualities are necessary for an ordinary surfer if he is to be worthy of Teahupoo.

The Hava'e channel has seen brave and ambitious surfers who lacked technique, ambitious surfers who had good technique but were short on courage and even professionals who were both brave and capable but lacked ambition. Andy Irons is the one who can truthfully say, "I have skill, technique, courage and the will to win."

At first sight, it seems that the Queen of Waves chose Andy. This was in 1997, when he was only nineteen.

"My first memory, even before seeing the wave, was of an enchanting village and its calm and welcoming people who were proud of the interest shown in their wave, their lagoon and the life of their fishing village. I cannot say how proud I am to be the first surfer to win a title at Teahupoo, although the conditions during that competition were not exceptional. For me, it was not just another tropical tube on the circuit. In fact, it was the beginning of a great adventure."

Andy's second professional victory was in the Black Pearl Horue in 1997, following his spectacular win in the HIC Pipeline Pro the year before. Born on the island of Kauai, he and his brother Bruce, sixteen months his junior, developed incredible talents for competitive surfing. He became one of the great Hawaiian surfing hopes. He quickly joined the ranks of the world elite but his fiery temperament did not fit in well with the inevitable constraints of the professional circuit. Andy was soon obliged to start again from scratch in his quest for excellence. It was at Teahupoo in the spring of 2000 that he brilliantly re-launched his career. On a colossal westerly swell that threw up square monsters of more than ten

feet, he beat Kelly Slater in the trial finals. Several months later, at Pipeline, he again beat the Floridian and their legendary rivalry has never been more brilliantly played out than on those two waves. In 2002, on his way to his first world title, he took two new titles, the Pipeline Masters and the Tahiti Billabong Pro.

That same year, during a free-surf session, Teapuhoo offered him a mutant wave that became a legend under the name of Black Death.

"I have never known why I took that particular wave nor how I got to the bottom of it," admits Andy. "My brother shouted at me to go. I knew that he wanted to kill me but I continued to paddle all the same. My instinct did the rest. It was like a rodeo ride trying to stay on my board on the way down but I resisted the temptation to let go. Teahupoo is a wave that never lets you down. It rewards any fidelity and confidence that you show it. If you have faith in it and make the right choice, it will unfailingly do its part. This is what happened that day. I believed in the wave and it in me."

Beating the world's best surfers on the world's most difficult wave gives a competitor enormous confidence. In the following years, Irons won all over the world: Huntington Beach, Pipeline, Teahupoo, Bells, J-Bay, Sunset, Hossegor, Mundaka, Tavarua, etc. Between 2002 and 2006, the Hawaiian won three consecutive world titles, four Hawaiian Triple Crowns and fifteen or so WCT titles. Ten years after his first victory on the Left at the End of the Road, Andy Irons knows what he owes to Teahupoo.

"My winning philosophy can be summed up in three words: make fewer mistakes. In surf, there are always small details needing to be corrected. That is the way you acquire experience and maturity. You have to learn from your failures and try not to repeat the same mistakes. And for putting such a theory into practice, Teahupoo is the perfect wave."

dusk to dawn

Paulo Moura as time stands still at Teahupoo.

Slow-motion but rapid progress at Teahupoo for the 2006 finalist, Hawaiian Fred Pattacchia

CJ Hobgood. One of the masters of Teahupoo.

Tha Brazilian Paulo Moura

'ā'ai

fa'ahiahia

ri'ari'a

tāmata

hanahana

tamari'i 'āi'a

vāhi ha'utira'a

mana

Glory

"Oh, my God!" The legend splashed across the mythical photo of Laird Hamilton at Teahupoo on the cover of the December 2000 issue of Surfer magazine, and famous around the world was an admission of the inadequacy of any other comment. The religious reference might even seem appropriate in the circumstances since big-wave surfers often have mystical tendencies and are prone to using religious terms to describe their feelings of glory and omnipotence while grappling with the elemental forces of nature.

Recourse to a supernatural explanation is understandable when faced with a seemingly superhuman phenomenon. The surfers' bible was simply expressing a commonly felt incredulity in the face of an extreme performance. "That wave is unsurfable!" could be the only reaction of young and old alike – not to mention confirmed unbelievers!

Five years later, in December 2005, Surfer stamped the identical "Oh, my God!" exclamation on a monstrous tube surfed by Shane Dorian at Teahupoo, reminding the surfing community of the superhuman nature of such exploits. This had been somewhat taken for granted since the appearance of the Millennium Wave photo and the obvious aim of the magazine was to revive the fascination and magic of such exceptional moments. One unfortunate result of the globalization of sporting exploits through the media, for whom immediacy is the supreme value, is that Teahupoo is now summoned to produce historic sessions at a frenzied pace if it is to maintain its legendary reputation.

The 2005 harvest was an exceptional one, with no less than four iconic days, including three Sundays, Days of the Lord for Lords of the Waves. These sessions were given the supreme honor in the Big Book of Big-Wave Surf of receiving their own individual nicknames. The first two, on May 1st and 2nd, have gone down in history as the Maydays. Teahupoo blew successively hot and cold, appearing on Sunday under its most forbidding aspect with hideously deformed faces and on Monday at its most idyllic, with unbearably blue tubes. It was perhaps the most perfect day since the media discovered the wave. During the September 11 and the October 2 sessions, nicknamed "9/11" and "Bloody Sunday" respectively, the surfers' determination to cover themselves with glory reached a new peak – and there were numerous casualties. When Teahupoo cuts loose like this, each wave is more venomous than a sackfull of rattlesnakes and an odor of the last rites floats in the air. However, many surfers seemed ready to die in their pursuit of glory. They did this however in a responsible, confident and serene way, fully aware of what they were doing.

The myth of Teahupoo, like all ancient myths, encourages man to transcend his limits. Those who stick to their known capacities never go forward. Laird Hamilton in August 2000, Malik Joyeux in April 2003, Shane Dorian and Manoa Drollet in December 2005 took their destiny into their own hands and earned their places in the history of surf. Such success is obtainable only by those who have always dreamed of it. And Teahupoo is still the only wave capable of procuring immortality for a surfer ... in less than ten seconds!

CJ Hobgood goes into orbit on one of the largest waves ever surfed by paddling. "When you get into position in the line-up on a day like that, you have to know just how far you are willing to go, how far you are willing to push your luck. Once you have stood up, there is no escape route. I thought it was an easy wave and I just stroked hard straight ahead. I could even have taken it deeper." 2 May 2005.

Today we know that certain waves are unsurfable by paddling. But in 1999 when Cory Lopez took off on the first "bomb" in Teahupoo's history, nobody knew what was or was not possible. "This was one of the first mutant waves and that day, it was the wave's moment of glory rather than mine," recounts the Floridian. "It literally swallowed me up at the end of the ride but many people, including myself, believed in it right to the end. I think that it was the suspense created by the wave and then its victory by KO that made such an impression."

According to a widespread belief, the encounter between Laird Hamilton and the liquid Tyrannosaurus Rex known as the Millennium Wave was a planned apotheosis, one of those minutely- and meteorologically-prepared feats by which elite big-wave riders and attendant cameras manage to keep track of the swell from across the world by internet and be there on the Big Day.

Unfortunately, this is not so. On the 17 August 2000, the Day of Days of modern surf, Laird and his team should have been in the plane returning from an exceptional trip to Tahiti, captured by Jack McCoy in his film *To' Day of Days*. The Hawaiian giant had just spent two weeks in the Polynesian waterman's paradise surfing waves ranging from one to ten feet, by longboard, body surf or on his incredible foil. He was about to depart when the swell of the millennium was predicted.

This detail might seem incredible at a time when big-wave surfers flatter themselves on their encyclopaedic knowledge of oceanography and meteorology. However, the team chose to delay its departure as much for reasons connected with the favorable aspects of the moon as with the promising weather charts. In Tahiti, every lunar month, known as *Ava'e*, has its own name and produces its own effects. Fishermen use this ancestral method for keeping track of the periods of maximum fish migration and for determining the most favorable days and nights for fishing. In Polynesia, one does not speak of a crescent or a full moon but of "emergence" of nights when "the fish are fat," "the spirits are abroad" or "the swell is strong."

That morning, at 4.30 a.m., it was a full moon, *Marama iti ia*, that guided the convoy of trucks loaded with material driving toward Teahupoo. This was an excellent sign. At 8.30 a.m., when the first large set reached the reef, all the actors of this historic day had the same conviction, that their presence was part of some grand plan. On his first wave, Laird decided not to go down into the slope, thereby escaping what would probably have been a serious accident. He then forced himself to warm up conscientiously, gathering vital information on each ride.

At 11.38, a mutant wave unlike anything ever seen before rose up from the depths of the Pacific. Laird released his rope and plunged with his board, shaped by his legendary father, into the history of the sport. He swept down the slope at full speed, straining on his foot-straps, and realized that the cavern forming around him was the size of an airport terminal. The wave seemed to double in volume every second and it was too late to retreat. He could only stick closely to his trajectory and maintain a constant speed for if he fell, his chances of survival were minimal.

Laird recounts:

"I was wondering what speed I needed to reach the bowl. This was why I used my hand to make that small turn when I reached the bottom of the wave. No one ever does that. It was a pure survival reflex. You can see that I transferred the weight of my body from the inside to the outside rail so that my board would point towards the channel. I knew that I could do nothing but be swept along. I didn't try to position myself deep in the tube. I just wanted to survive."

It was impossible to choose a line across the face of the monster. Laird had to surf where the wave dictated. If he had lost speed, he would have been relentlessly sucked back into the wave. Although he was in fact at full speed, he appeared to be in slow motion. He seemed to freeze for a second as he reigned supreme over a chaotic universe and at that moment the most famous photo in the history of surf was taken, giving a wide-angle view of the exploit. It was the last frame on the roll of film, a further miracle to mark the day. Laird's partner, Darrick Doerner, was to say later. "At that time, there was only one man on earth who could surf that wave. And that was what he did."

Pushed toward the channel by a wind-gust of incredible violence, Laird realized that he had just ridden the wave of his life and had thus reached the end of his quest for the unsurfable wave. Back in the boat, he put his head in his hands and wept the silent tears of a man who knows that he has just realized his dream.

"It was a very short ride but I had to dig deep into my physical and emotional resources. I was on a knife-edge, at the limit of my capacities. Every time that I speak about this event or see the film or the photos, my veins fill with energy and my pulse beats more strongly. It took me two weeks to get over it. Perhaps I will never get over it completely."

Garrett McNamara wearing a helmet mounted with a camera so that ordinary mortals could have a first-hand experience of the inside of a tube. 22 August 2002.

On 29 April 2003, Malik called me up at 5 a.m. He knew the waves were going to be big at Teahupoo and he needed a ride down. I picked him up at dawn on the side of the road. He was bare footed, wearing board shorts and a T-shirt, clutching two salvaged boards, his sole possessions.

He did not know it yet but within a few hours his life was going to change. Nature was going to kick-start his career. One of the biggest southwesterly swells of the decade was pulsing on the treacherous reef break. Every set was a foot bigger than the previous one. Soon the glassy perfection of the line-up turned into a dark dredging machine sifting the whole ocean into the lagoon. The paddle surfers slowly retreated from the line-up as the jet-skis started to swing the tow-in surfers into action. Malik was right next to me on the boat from which I was shooting.

He had been looking at the conditions and you could tell by his eyes that all he wanted to do was experience one of those monsters from up close.

Teahupoo fascinated him. This wave could satisfy his need for adrenaline. He knew this wave was a gift for him, as well as a gift for all Tahitians. He had been towed-in only once before, during a massive south swell in July 2001. At the time he charged on a couple of waves and even scored the cover of the *Surfer* Big Issue a few years later with a photo of that session. This time Malik was offered a first ride around noon, a massive perfect tube that seemed like the bomb of the day. He was brimming with confidence although his board did not feel quite right.

Suddenly the engine cable on our boat snapped and we began to drift into the impact zone. We had to be towed back into the marina by another boat. The waves were getting out of control. We could not stop looking out at the reef from the marina. We had got to get back out there. Something was going to happen. Malik wanted another go.

Local surfer Alain Riou offered to take me out with his dinghy and I told Malik to grab a board and head out with us. The dinghy barely made it out through the channel, so strong was the current pulsing from the still-rising swell. I soon realized that shooting from such a small boat was going to be very dangerous in these wild seas and the jet-ski drivers possibly wouldn't notice Malik. As luck would have it, I caught Kin Kin's eye – one of the best boat drivers around – coming back from a successful *mahi-mahi* fishing run. Being a surfer himself, he offered to finish off the day positioning us at Teahupoo to check the action. We hopped onto his boat and got right back into pole position in the channel.

Raimana came by our boat a couple of hours later and offered Malik a last ride. Malik did not hesitate even for a split second. He put on a life vest and jumped in the water. He had been waiting patiently all day for those one or two moments where one of his brothers would give him a go. He had paid his dues paddle surfing at Teahupoo and nothing scared him. He would often stand up at the back of the boat and follow the jet-ski pilots to make it clear that he was ready at any time they had a break. A few minutes later the real bomb of the day was moving in and Raimana was carefully positioning Malik in the sweet spot. "Wait, hold on, hold on.... O.K. Let go!" yelled Raimana. Malik dropped the rope and held his line down a 30-foot wall as the wave started exploding around him. The spit of the tube nearly torpedoed him into oblivion, but he managed to stay on and made it to the safety of the channel.

At the ripe old age of 23, Malik Joyeux had just ridden one of the most dangerous waves ever. The crowd went wild. Before that ride, the size reference at Teahupoo was Laird Hamilton's incredible wave in 2000. Raimana, Vetea David, Garrett McNamara, Strider Wasilewski, or even Tahitians Didier Tin Hin and Nicolas Lee Tham had scored some monsters during that same swell or previous ones, but all agreed that Malik's wave was the biggest ever challenged at Teahupoo. He had set the new record and had made a name for himself instantly, subsequently winning the 'Tube of the Year' award of the Billabong XXL Big Wave awards.

Malik Joyeux, A wave to reward his lifetime passion for the ocean, 29 August 2003.

Manoa Drollet. A wave that for many has its place in the top three biggest ever surfed at Teahupoo. 2 October 2005.

Doug Young, 15 October 2006.

Manoa Drollet, 28 July 2006.

shane DORIAN

During the winter of 1992, Shane Dorian, then aged twenty, ventured out with Todd Chesser and Brock Little onto the outer reef of the North Shore in Hawaii in search of strong emotions. After forty-five minutes of strenuous paddling, they confronted the 25ft monsters that had sowed bedlam in the ocean all around them.

"I decided to have a go," recalls the Big Island surfer, "just as a huge set blocked out the horizon. I was so anxious to get on a wave that I took the first one of the set. I had no chance of getting through and was thrown into the void. I was so badly shaken that I lost and regained consciousness like a light being switched on and off. I was foaming at the mouth and I had no sensation in my legs. That day, I realized for the first time that I was mortal."

Teahupoo, 2 May 2005. Fifteen seconds can seem an eternity when one is strangled by a leash and finds oneself on the bottom under tons of frenzied water. Shane was again acutely reminded of the fragility of humankind. Gesticulating like a pitiful puppet and trying to free himself from the stranglehold of the leash, he had to heave himself toward the heavens for fear of ending up there definitively. On the boats, they thought that he was done for. The tube devoured him as a killer whale devours its prey, while a mother shielded her daughter's eyes, some of the onlookers crossed themselves and others uttered expletives. Fractions of a second went by. After two waves under the water, Shane emerged, with the halo of a real survivor.

"Even after many years' experience surfing big waves, you pay a heavy price for any error. To be towed onto this bomb on my seven-footer, without a life jacket but with a leash was definitely not the thing to do. I sinned by excessive self-confidence in releasing the rope too soon. Above all, it was because I confused two separate things – paddle-in and tow-in – that I ended up on the bottom. Personally, I prefer to paddle until it is impossible to continue. You will never see me behind a jet-ski on a wave that can be surfed by paddling. I prefer to take ten waves paddling than a hundred by jet-ski. It is much more satisfying. But that day, at Teahupoo, one had first to choose one or other of the techniques and then select the wave accordingly."

The day before, the swell at Teahupoo was more westerly, grey, threatening and smelling of the emergency ward. Shane and Brock's team was the first into action, even before sunrise. Shane's inextinguishable desire to surf these knife-edge monsters, his perfect backside technique and his unique knowledge of the tube made him the hero of the day. At the end of the session, the other surfers gave him a standing ovation, something quite unprecedented. Shane's reaction was, "The 1st and 2nd May 2005 were the pinnacle of my surfing career."

At thirty-three, Shane thus encountered fame and glory, honoring his rendez-vous with destiny and opening the doors of the Hall of Fame. He was born in 1972 in Kona, on Big Island in Hawaii. His father was a former actor, Hollywood stuntman and stand-in for Elvis Presley. His mother had in her youth competed in female body-building competitions. Shane was fifteen when he moved to the North Shore to try to break into the surfing world. He quickly made a name for himself at Waimea Bay and Backdoor before turning professional and joining the New School movement under the charismatic leadership of Kelly Slater. He became one of the pillars of the Momentum generation who became stars thanks to the films of Taylor Steele. Although eternally second in finals at Pipe Masters, Eddie Aikau or Teahupoo, Shane nevertheless won several important victories – at Bells, Billabong Challenge or Mundaka – and was fourth in the World Title in 2000. In 1998, he won the leading role in the Hollywood super-production *In God's Hands*. The surfing confraternity never really forgave him for turning actor but at least the film hastened his encounter with the world of tow-in, on the giant waves of Jaws.

Retiring from the circuit in 2003, he joined the Billabong Odyssey adventure, tracking down the largest waves in the world. Three months after the historic Maydays sessions, he shot the tube of his life at Teahupoo, winning the Billabong XXL trophy for the best performance of the year. He admits to still thinking about this wave every day:

"I am conscious that nature gave me a marvelous present. Even if I sit on my jet-ski at Teahupoo for the next ten years, I will perhaps never again see a wave like that."

Shane Dorian, "Without doubt the most important wave of my career," 11 September 2005

laird HAMILTON

He is the ultimate waterman, a seashell in which one can hear the sea and on which the sun and salt, the joys and travails of the ocean have left their mark. Laird's sporting philosophy is one of adventure in its purest form. This is why he seeks freedom and the unknown, why he needs to explore and to fracture existing codes.

"I want to go faster on the water and surf bigger waves. I want to invent new aquatic sports and to mix existing ones. I want to be creative," he declared, after beating a windsurf speed record at Port-Saint-Louis in France at the age of twenty-two.

Laird has constructed his legendary persona as King of the Waves by becoming a powerful and methodical all-rounder, without any frills or concessions to fashion. From the very beginning of his career, his ambition was crystal clear: to seek far horizons, far from the beaten track and existing limits.

"I have always avoided competitions because I have seen too much injustice. I don't want my performances to be judged by anyone else.... Surf is a means of expressing and constructing my own personality. I want to be my own judge."

Laird was born in a bathysphere (reduced-gravity capsule) as part of a scientific experiment at the University of California Medical Center in San Francisco. He trod the sand of the North Shore of Oahu only a few months later. Under the guidance of his mother, Joann, he learnt to surf between the ages of two and three on the front half of a board. One day on the beach he met Bill Hamilton, a legendary surfer of the sixties, and took him home to introduce to his mother the man who would finally become his adopted father. Bill recounts the day that he drove Laird onto the cliffs at Waimea Falls that loom 60 ft (18 m) above the water. Laird looked down, turned toward his father and without a word,

jumped off the cliff. "He's been bold since day one, and hell bent on living life to the extreme."

A taste for risk is an essential part of a child's contemplation and testing of the real world. Even after acquiring his imposing physical presence, Laird has retained the clear-eyed and elfish expression of one who is constantly out to test his own limits. The greater the risk, the more abundant the adrenalin, the greater the merit. This enduring characteristic has led Laird to consider all the giant waves of the planet as so many Himalayan peaks to be conquered. He was the first man to reach the summit of the liquid Everest that is Jaws with its waves of 60ft and more; he has rowed across great expanses of water all over the world; he has been a stuntman in a James Bond episode; he invented tow-in and foil surfing. But it was in August 2000 at Teahupoo that he made his definitive mark as the dinosaur of surfing history.

"It has always been my aim to surf the unsurfable. I had long thought of being towed-in at Teahupoo and of surfing the waves that we had all seen in photos but which no one had dared surf – unreal, comic-book waves. It was as if the wave was summoning me to surf it."

What about fear? There exist big-wave riders who defy it, shut it out at each wave and who wake up one day too overwhelmed by it and retire from combat. Then there are others who ignore fear, not through contempt for danger or lack of imagination but through an inch-perfect preparation and total lack of arrogance. Laird is one of the latter. "I have already been stuck on the bottom several times.

Thrust down into the abyss, you have the impression of being buried alive and you reflect on life. We are just specks of dust up against the power of nature. I only hope that this wave has helped to show people how exceptional the ocean is and how much work and talent it demands of surfers. This should earn us respect as athletes."

Laird admits having changed after the Millennium Wave, an exploit that propelled him and the sport into another dimension. "Surfing such a powerful, beautiful and terrifying wave brought with it a feeling of peace that I cannot explain. It is like driving at 120 mph for the first time. You experience a fear unlike any other. Once you have reached this level of adrenaline, you cannot retreat or take your foot off the accelerator. You have to find something even more extreme."

shadows

The right-hander on the other side of the channel.

Vetea David

Raimana Van Bastolaer.

'ā'ai

fa'ahiahia

ri'ari'a

tāmata

hanahana

tamari'i 'āi'a

vāhi ha'utira'a

mana

les héritiers

In *maohi* society, the custom is to give in order to receive. This is considered a simple social obligation. Gifts and counter-gifts are the basis of the millennial Polynesian traditions and reciprocity is considered a fundamental form of politeness. This moral imperative concerns not only material exchanges but also those of words, thoughts and symbolic acts.

In Tahiti, it is not rare to see a surfer carefully place a flower or a pebble in the lagoon before paddling out to confront the swell. He pays his debt to nature with a prayer and a modest offering to show his complicity, his profound respect and his desire for beautiful waves. "If you give, you receive ten times more in return," says a local.

Tahiti is one of surfing's original birthplaces. Two hundred-year-old texts and numerous oral legends testify to the ancestral practice of *horue* in the Society Islands. With the arrival of the Europeans, surfing disappeared until the 1960s. However in the following thirty years its devotees suffered from a terrible sense of isolation, in spite of the dedication and passion of the pioneers who sought to re-launch it. Today's Tahitian surfers are worthy heirs of the warriors who on their boards or in their outriggers rode the waves that delineate the channels which in turn mark the boundaries of their territories. They symbolise the rebirth of *maohi* culture and its traditions of generosity, exchange and hospitality.

In the new world order of surf, Tahiti has conquered a place apart without in any way sacrificing its tender soul to modern notions of progress. However, the practice of gift and counter-gift has sometimes been rather uncertain at Teahupoo. In a famous episode, the Tahitians agreed to tow the team of professionals sent by a leading magazine in return for a promise to have a local surfer on the cover. Unfortunately, this promise was never kept. This lack of reciprocity is underlined by the question asked by the Tahitian poet Henri Hiro of *popa'a* and of colonizers of all sorts. "If you had come to my place, I would have been able to welcome you but in fact you came to your own place. How can I welcome you?"

The history of the Millennium Wave throws a further more complex light on this problem. Local surfer, Vetea David, the official sherpa who, in 2000, led Laird Hamilton to the summit of the greatest challenge in modern surf, does not share the idea expressed by the driver, Darrick Doerner, that Laird was the only man on earth capable of surfing the wave. "In terms of generosity, Laird is beyond reproach, a man with a big heart who loves sharing his inventions and his huge experience. But personally, I consider on reflection that I made him a present of our wave. Tahitians have learnt much from this episode."

Jean-Jacques Rousseau, the great French philosopher of the Enlightenment, long tried to promote the myth of the New Cythera, a Tahitian paradise inhabited by perfectly natural beings, where private property, envy, jealousy and prejudice were unknown. But he described a civilization already in its death throes, plunged into disarray by confrontation with western culture. Before his death, he made this pronouncement on which the heirs of Teahupoo will one day have to meditate: "If the guests are too numerous, then hospitality is destroyed."

Tahitian, French and European Champion in the eighties, Arsène Harehoe is a Tahitian surf legend, a master venerated by all. Over the last twenty years, Arsène has been present every time something significant has happened in French Polynesia. He continues to write his own personal legend on the waves just as he did on this magnificent day. December 2006.

Alain Riou, winner of the trials at Teahupoo, is one of the rising stars of the younger generation of Tahitians.

Alain Riou, Heimata Caroll, Malik Joyeux, Kevin Johnson.

2006 Billabong Pro Quarter finals. Hira Teriinatoofa, the local who has dethroned more TOP 40 stars than anyone in the history of this contest.

Kevin Johnson, assiduous student at the Tahitian Tube School, busily revising his classics at Teahupoo

Manoa Drollet's movements in the tube resemble an inspired and graceful dance, never disrupted by brusque movements. His incredibly relaxed stance and exceptionally smooth trajectories make him the ideal surfer for having a board-mounted camera or for underwater shots, capturing his incredible powers of interaction with the wave tat will never cease to astonish.

Michel Bourrez. Junior World Vice-Champion 2004, European ASP Champion 2006. This Tahitian is making a name for himself on the professional circuit around the world, but does not forget to appear at Teahupoo, a mandatory showcase for ambitious young Tahitians.

Few spots can offer a young local boy the chance to qualify for an international contest and confront the world champion. Heiarii Williams, winner of the 2006 heats, realized this dream when he competed against Kelly Slater.

raimana VAN BASTOLAER

This old poster with faded colors and edges damaged by sticky tape and drawing pins is an original Tahiti Pro 1998 poster. The photo shows Raimana Van Bastolaer in a small tube with his radiant smile and doing a double shaka to show how at ease he was. It is framed by *tiaré* flowers and under the name of the competition is written, *"The Tahitian Dream."*

The whole thing has an air of tranquil perfection, light years away from the savagery associated with Teahupoo in the following decade.

"It was a time of innocence," reflects Raimana ruefully, "before we realized how violent the wave really was. It is true that there is an idyllic size at Teahupoo, around 5ft with an incredibly open blue tube perfectly connected to the west bowl and offering the surfer a direct view of the mountains. This was something very powerful and we cannot forget it. This sort of surf is 100 percent Tahitian and must be savored solo or with a few friends as it happens and not afterwards, as with tow-in."

A former body-boarder later converted to surf, a goofy-footer in the kingdom of lefts, Raimana is not technically speaking a surfer of the stamp of the stars of the pro circuit. He owes his international stature to Teahupoo alone and to his audacity in the massive conditions that have made the reputation of the Hava'e wave.

"When the wave is a twelve or fifteen or twenty-footer, and you are in the tube with tons of water swirling above your head, you are in a universe apart. Sights and sounds are completely different. It is very difficult to describe. For example, on small waves, the boats are on the same level as you are. On enormous ones, they rise above your head and then plunge down as if on a roller coaster. You often wonder, "Why are they speeding out to sea? What are they trying to escape?"

As a true ambassador of Tahitian surf, Raimana, with his numerous contacts all over the Pacific and beyond, has progressively become the mandatory correspondent of the surf industry, riders' teams and film crews. When the wave season is in full swing, he has to go into top gear to meet all the demands made on him for he has the confidence and friendship of the greatest champions. He is "consulted" as a travel agent, an impresario, a coach, a driver, a confidant and an unbeatable expert on Teahupoo and the Polynesian islands, always with the bonus of the trademark Tahitian smile offered like the traditional garland of flowers. When he is not in the water defending his reputation as one of the best frontside surfers of the spot, he is

gesticulating from the upper deck of his boat, the *Raimana World*, signaling the approaching sets to everybody, without favoritism or distinction of nationality. For Raimana is everyone's mate.

The times being what they are, he owes his celebrity not so much to his status as Tahiti's hospitality ambassador or to the dozens of huge waves that he has conquered in his ten-year career at Teapuhoo, as to an event that is known world-wide. On 1 May 2000, at the beginning of one of the most widely reported tow-in sessions at Teahupoo, Raimana was towed by the Hawaiian, Reef McIntosh, onto a 12ft wave. Badly positioned, the driver was caught by the roller, which dragged him relentlessly down the slope. Forced to abandon the jet-ski he ejected half a second before it tipped over with the lip. It was only inches away from Raimana's head – he was in the tube – and was then dumped on the dry reef.

"First I saw a shadow in the wave above me. I wondered confusedly about my jet-ski and where my driver was. As a reflex I ducked my head, which doubtless saved me. After that, I was blinded by the spray and finished the wave without realizing what had happened."

As to whether possible excesses in the publicity of the wave might lead to dangerous conduct in the competition for extreme results, Raimana dismisses the hypothesis with the resigned but optimistic smile of all Polynesians.

"Everything is fine. I do not think that the village of Teahupoo and Tahitian surfers regret what has happened over these ten last years or that we have given birth to a monster. Not at all.

The spot is magnificent and the wave will always be there. It is up to us Tahitians not to change."

vetea DAVID

"The first time that I surfed at Teahupoo was in 1989," says Polynesian waterman, Poto, with emotion, his weather-beaten face lighting up at the simple recollection.

"I had just returned from the Pipeline Masters where I finished second to Gary Elkerton by only 0.10 points. I was alone and the wave was enormous, more than 10 ft. I took tube after tube, upright and blown out of my mind. I spread my arms wide and looked all around. Everything was enormous and perfect with a gusting wind and all the trimmings. Every one of those waves would have allowed me to win the Pipeline Masters! I said to myself, 'This is my dream as a surfer, a tube even more intense than Pipeline,' but I was a long way from realizing that this wave would one day become as important as Pipeline."

Vetea "Poto" David was at the very beginning of his career when he discovered the Wave at the End of the Road. Three years earlier, in 1986, he had won the junior amateur world title at Newquay, England, beating Nicky Wood. There followed ten years of a career on the Tour with regular incursions into the world Top Twenty and some exceptional feats in Hawaii. In 1988 he was declared the Triple Crown's Rookie of the Year. He was finalist in the Marui Pipe Masters the following year and his powerful brand of surf allowed him to win his spurs as a respected North Shore surfer. "In Hawaii, I could really give full expression to my surfing but the rest of the circuit was a torture. Each year we went three times around the world to surf rubbish waves."

From the earliest age Poto had polished his trajectories and his backside technique under the devastating lip of Tahiti's imperial wave, Taapuna, but for a long time he had no boat or car to explore other spots on the island. He had nevertheless amassed some solid experience of big surf on the reef at Maraa where there is both a right and a left surfable by paddle-in. "The three Faraire brothers who came from the peninsula and of whom the eldest had been champion of Tahiti never stopped talking about Teahupoo. Even my big brother Moana had been there but I had never ventured so far. When the surf was big, I might hitchhike as far as Vairao. Nobody surfed regularly at Teahupoo since it was considered deadly. It was considered better to surf a cool wave like Vairao rather than to go alone to Teahupoo, just for the glory of it. I have to admit that, quite frankly, we were not equal to it. Lots of guys will tell you that they have surfed at Teahupoo but it will have been on waves of 6ft and less.

Retiring from the circuit in the mid-nineties, Poto devoted himself exclusively to the waves of the Tahitian *fenua*. He is today without doubt the surfer who has surfed the greatest number of giant waves at Teahupoo by tow-in. "Teahupoo is my gold-mine and not only mine but that of all Polynesians. It is a quite unexpected stroke of luck for us to be able to earn a living by free surf. For twenty years, guys have lived on their courage in Hawaii but now we have finally found our own Tahitian pearl."

"When the going is really rough, Poto is the unchallenged master of Teahupoo," declares Kelly Slater, a great admirer of the local lad, "He is always perfectly positioned, has the right timing and never falls. He does not take the same risks as Shane, Garret or Malik but he constantly surfs in the biggest swells and takes more waves than anybody else."

"There is surfing and then there is surviving," says Vetea, "Everyone has pulled back at one time or another. Each of us has had a narrow escape, the very best as well as the run of the mill. If you are not well positioned, you do not take off. The spot can be fatal. I want to surf the big waves but without taking unnecessary risks. I know how one can be battered and I have made my contribution. I have been doing tow-in in Tahiti for more than ten years. And I shall doubtless be there in another ten years' time."

Vetea dreams of opening his own surf school in order to allow the young ones to profit from his colossal experience. He explains to any prospective heirs that without a lot of hard work nothing important can be achieved.

"Tahitians are often frightened of the big waves but it is not their fault. Tahiti is not a surf Mecca. We have a dynamic federation but it has not the structures of, for example, the French federation. In Hawaii, the young ones leave school in the middle of the afternoon to go and carry stones under the water, row their outriggers in tandem so as to become experienced watermen. I have a lot of respect for the young generation who are prepared to measure up to Teahupoo, but they must follow the Hawaiian example if they want to take up the challenge effectively."

'ā'ai

fa'ahiahia

ri'ari'a

tāmata

hanahana

tamari'i 'āi'a

vāhi ha'utira'a

mana

Playground

The French language is a precision mechanism that has a word for everything and continually invents new ones as the need arises. In the eighties, the French surf-film producer Yvon Bocqué – to whom we owe the mythical series *Tahitian Dream* – transformed the normal usage of an existing word to produce the concept which he called 'glisse.' This was a generic term for sports in which there was a sliding action, whether over the air, snow or water, leaving an ephemeral imprint on the element concerned.

To wind-surf, to body-surf, to body-board, to kite-surf, stand-up paddle surfing, tow-in surfing – most of these sports have only an approximate equivalent in French or Tahitian. The all-purpose term 'glisse' assembles all of these under the banner of pure, extreme performance and of the osmosis between the power of nature and the technical mastery of the athletes.

As soon as the first photos of Teahupoo appeared, specialists in these sports from all over the world could not wait to shoot the monster and secure a few lines in the history of their sport.

Technically, the body-boarders were best able to make their mark. In the late eighties, Mike Stewart and Ben Severson were the first professionals of any sport to reveal to the world the potential of the wave. The configuration of the reef is in fact perfectly suited to the body-board. As at Pipeline, the horizontal position allows more precipitous take-offs, and consequently deeper tubes, than in board surfing. Body-board also permits more spectacular exit manoeuvres. As the premier competition on the world circuit, Teahupoo restored the prestige of body-boarding and moved it onto a new plane. On days when there is a heavy swell, at first light, the line-up is peopled by a few hardcore body-boarders such as Simon Thornton, Baguette, Ryan Hardy, Damian King, Dean Fergus and local boy, Nicolas Richard.

Though Teahupoo is a body-board Mecca, it is not well suited to wind-propelled sports. The Tahitian wind-surfing champion, Robert Teriitehau, who in 2005 repeated Jason Polakow's exploit five years earlier in being the first to wind-surf the Teahupoo wave, explains, "The Hava'e channel is not specially well known for high winds. Some wind can come from Maraamu but it is unpredictable and can have an unfavorable effect on the wave. You have to find enough wind to get you down the face of the monster and then try to exploit the wave without falling."

After such feats, the kite-surfers did not want to be upstaged and the sport's stars, Jérémie Eloy, Julien Sudrat and Martin Vari produced some historic sessions in 2005 and 2006 sometimes in waves of more than 13 ft (4 m).

Certain attempts to confront the wave on improbable craft such as outriggers, kayaks or even inflatable inner tubes saw their daredevil riders pay a heavy price for their lack of respect. Teahupoo is a unique aquatic playground but only those with perfect mastery of their craft can express their creativity there.

Jérémie Eloy

On the left Martin Vari; on the right Julien Sudrat.

Robert Teriitehau, 1er Septembre 2005

Didier Tin Hin.

Jason Polakow

David Rastovich. Kick out. Having fun while competing.

Rasta. Cut back. Seriously free surfing.

'ā'ai

fa'ahiahia

ri'ari'a

tāmata

hanahana

tamari'i 'āi'a

vāhi ha'utira'a

mana

Mana

Mana is the power of sorcerers, the magic of stones, waves, clouds and trees. It is the sacred word in Tahitian esotericism. In the real culture of the third millennium, it will always be associated with the extraordinary and tragic destiny of Malik Joyeux, the "Petit Prince" of Teahupoo.

Tahitian esotericism is based on a mystical intuition, which is supposed to lead to a profound grasp of the real world, either through reception of a secret message handed down over the ages or through a personal quest. The latter is the case of those who confront, without arrogance, the most dangerous waves in the world. They are a chosen few. Today, the different manifestations of Polynesian esotericism are fused in the word *mana*. In everyday language, it signifies "power," "strength," "truth," "destiny" and other concepts associated with success.

Possession of *mana* is confirmed by success in any given undertaking: the fisherman who regularly has good catches, the farmer who has excellent harvests, the artist who creates major works or the sportsman who performs exceptional feats. These "winners," like Malik, all possess *mana*. They receive it from the spirits via the ancestors or directly from the gods or the cosmic forces. It can be retained if one proves oneself worthy of it, otherwise it is withdrawn. Recipients of the gift are expected to develop it and put it to good use.

Mana confers protection against both danger and malevolent spiritual forces. It must be reinforced by the performance of appropriate rituals and by showing respect for nature, which has provided the key to success. More suspect after the intrusion of so-called progress and the western mentality, *mana* has sometimes been used in corrupted connotations, amounting to no more than simple superstition. Acts that now seem to us supernatural were for the ancients quite natural events, rooted in everyday life.

Malik became first a demigod because of his exceptional feats at Teahupoo and then a martyr after his dramatic death in the waves of Hawaii. He personified the renewal of the Tahitian communal identity symbolized by the *mana* of these modern heroes, the surfers of the *fenua*. His integrity, his angelic smile and his bravery in the most extreme surfing conditions, all indicated the presence of the mysterious power of *mana*. His obvious sincerity and unassuming demeanor, together with his astonishingly direct and charming gaze gave him a charisma that subjugated all who met him and that was the emanation of the accumulated spiritual powers of generations of Tahitian wise men and warriors. Malik was born under a lucky star and was one of life's magicians, with an exceptional gift for happiness, all of which gave him huge influence.

Mana is however not only an inner, all-powerful force, but is also subject to fate – for better or for worse. And when, like Malik, one spends one's time defying death, one can only win by losing definitively.

In my eyes, he was the best surfer in the world. This was not because he had won world titles or surfed the biggest waves but because he personified what I take to be the essence of surf: being attuned to the wonders of nature. Malik wore his love of surf on his face in the form of his trademark angelic smile. Anyone who met him, or especially who surfed with him, could not but be moved by his love of life.

He was brought up on the tropical French Polynesian island of Moorea. He began to surf at the age of eight and was fourteen when I first met him on the North Shore in Hawaii. The skinny little blonde lad from Tahiti had already made numerous friends among the kids of the respected local surfers since there is nothing like a bit of Polynesian brotherhood to enable you to get by on the North Shore.

At sixteen, Malik was already dipping into the biggest waves at the famous Teahupoo reef break. Soon his name and image were to be found in glossy double-page spreads in the principal surf magazines around the world. However, at that time, Tahitian was not the best nationality for interesting the industry's clothing giants. American, Australian or European surfers were better placed because of the size of the targeted markets.

Malik had a very simple ambition: to make a living through surf. He did not demand much, just enough to allow him to express his talent on "his" waves. For years, he, his older brother Teiva, his younger sister Thylane and his mother Hélène lived in a hut near the famous spot of Haapiti on Moorea. They had none of the luxuries of western kids: hot water, TV, cell phones or cars. They lived with the strict minimum but were completely happy. Their strength was the family and the love of nature. Their little hut was immersed in nature. It had no walls, just a wooden structure with a roof, surrounded by ferns and palm trees. For them, this was paradise. Their favorite playground was the Pacific Ocean just a few feet away.

Big brother Teiva had managed to turn professional wind-surfer and kite-surfer and had moved to Hawaii to pursue his career. Malik began to get some minor sponsorship deals for clothes and boards, as well as a few airline tickets.

He would see the highly-paid professionals turn up at his local breaks every year and would dream of the day when he would have a car and be able to build a house for his family. He was not in any way envious, just wanting to be a part of the show. His local break was soon to become the most publicized wave in the world. With their innate tube sense, the Tahitians were riding it better than anyone else but none had a contract that would set them up for life. Malik believed that he could have one.

This boy was smart. He could rebuild a computer in a matter of minutes, construct a web-site or work with the most sophisticated 3D software. He could have landed a well-paid job anywhere in Papeete, but he was interested only in surfing, in being in the water. Finally, as his exposure increased, his sponsors started to pay him more reasonably but still only enough to scrape by. He was an easy prey for unscrupulous sponsors such as the sunglass manufacturer who used his image for three years without paying him a cent. He never seemed to have enough money to get himself a proper quiver. He had two or three boards at the most but they lasted no longer than a couple of days at Teahupoo on a big swell.

For the Tahitian surfing community, he was the little brother whom everybody tried to help, receiving much in return. He listened to any advice and knew that only hard work would enable him to get where he wanted.

On 29 April 2003, Nature gave an exceptional boost to his career. In one of the biggest southwest swells ever encountered at Teahupoo, he triumphed on one of its largest and more dangerous waves. This historic performance won him the Tube of the Year trophy as well as the recognition and respect of surfers around the world.

Influential surf photographers and cameramen immortalized Malik's wave and he soon made the headlines of the surf magazines and was the star of numerous DVDs devoted to this historic day. Raimana Van Bastolaer's expert driving contributed greatly to this triumph but it was Malik himself who captured the magical moment. It was his attitude to life and to the ocean that had got him where he was. His motivation and his whole-hearted approach were finally rewarded. Teahupoo had given him a marvellous gift and a chance to realize his dream. He had not let it pass him by. He had been in the right place at the right moment and had surfed the wave like a champion.

Finally, luck was smiling on Malik. Several months earlier, he had fallen in love with a Polynesian princess called Kamakea, who was completely hypnotized by his energy and spent entire days helping him in his quest for excellence.

Malik did not allow his success to go to his head and remained as humble as he had always been. Everywhere he went, people greeted him with smiles and spoke of his exploits. In a few seconds, Malik had

Malik Joyeux. Total technique, total commitment. Gotcha Teahupoo Pro 2000.

gained more media coverage than many professional surfers in their whole career. Teahupoo had the power to boost the career of a surfer with a single wave. Malik Joyeux became a name known to every surfer on earth. He was a talented and courageous young Tahitian who was an excellent tube-rider and a great career as a big-wave rider awaited him.

During the two years following this triumph, Malik linked up with another master of Teahupoo, local boy Manoa Drollet. They had understood the importance of forming a real tow-in team and building on the experience gained at each outing. Their new sponsor, Oxbow, financed the purchase of two jet-skis and began to record each of their sessions.

The 2005 Teahupoo tow-in season was extraordinary with no less than four massive swells. The experience and the consistency of Manoa and Malik were remarkable. From dawn to dusk they threw themselves together onto the monsters with an insatiable appetite. Their performances on the May 1 and 2 and from September 11 to 26, 2005 earned them the title of the Teahupoo Dream Team. For the single year of 2005, their press book was as full as that of some top WCT surfers. Not bad for two isolated young Tahitians!

As if to complete this success, Malik and his brother Teiva won important roles in a film with a $10 million dollar budget. Trials began in Tahiti in 2005 and the two brothers literally leapt out of the screen, especially in a poignant scene in which Malik saves his brother from drowning. Malik had always been interested in surf filming. No month went by without his inventing a new way of filming waves or constructing a new watertight housing for his camera. Now he had the chance to work with the best cinematographers and to film in the waves with a heavy 16mm camera which he manoeuvred with as much grace as when he surfed, finding new and astonishing angles.

Filming was to start in early 2006 in Hawaii and in Tahiti. Malik was to become a real modern hero, a surfer capable of transmitting to a wider public the very essence of surf. His life was an ocean of laughter, respect, innocence, friendship and generosity.

The Maydays sessions, 2 May 2005.

One of Malik's favorite photos. He was particularly proud of this ride and suggested several titles for the poster – a la "Facets of Darkness" or "Playing in the Dark." 1 May 2005.

Malik and Kamakea, 29 April 2003.

He personified a new generation of athletes; ones with integrity, capable of sharing real emotions and not simply the kind of emotions born out of the conquest of a world title or the largest wave ever surfed. His emotions were very simple, arising out of his love for the ocean and sharing its secrets and its beauty. Malik's life, personality and smile were for many simply the greatest show on earth.

He amply deserved all this success. His manner and his charm were irresistible. This is why he will always be our "Petit Prince de Teahupoo," a real ambassador for Tahiti. This happy soul was cut down in his prime, in Hawaii, where a wave snatched away his life on the morning of 2 December 2005 at Pipeline. This wave sent Malik to Paradise and all of his friends into deep despair. He was only twenty-five. The world of surf now has its James Dean, a romantic and mythical hero capable of inspiring millions. His name is Malik Joyeux.

Tim McKenna, December 2005

Farewell to Malik at Teahupoo, 18 December 2005.

beneath the waves

Acknowledgments

My parents for your love, unconditional support and advice throughout my career. I could not be where I am now without you.

My wife for your countless hours of work keeping the project rolling and coordinating the entire production. For your love and for giving me the joy of my life, Kaelan.

My bother Ross for moral and financial support.

My uncle Geoff Juckes for getting me that first Nikon FM2 body and setting me off in life with a passion.

Gilles Hucault for your friendship, professionalism and dedication to the cause of the Tahitian surfers. Your footage is a goldmine and your heart a true diamond. Love to Patoue and Vanille.

Mike Gandouin (and his beautiful wife and daughter Sabrina and Vaimiti) for sharing with me the intricate secrets of colours.

Jerome Bazile, Marama Drollet and Nicolas Gandouin, my friends and assistants, for their invaluable support throughout this project helping me to handle the workload.

Guillaume Dufau for taking on the huge task of creating the texts for this project and for your help and dedication in making it happen. Your ability to grasp what makes a person, a situation, a moment, is truly unique. We love your words and who you are even more.

Jack McCoy for all the great moments at Teahupoo and elsewhere. For getting me hooked on underwater photography and for making the best surf movies that I can remember. Thanks for the inspiration and my love to the family. Marc-Antoine Bouvant for all the good times and being so creative and unique.

Marc-Antoine Bouvant for all the good times and being so creative and unique.

Phillipe Chevodian for always keeping in touch, and making me the lightest housings around.

Laurent Sarrailh and Mathieu Walbrou I hope you appreciated the show from above.

Malik Joyeux: my brother, not a day goes by without the echo of your laugh or the vision of your smile. We miss you so much. My love and support to all your family, Teiva, Nina, Thylane, Helene, Jeromio and your beautiful princess Kamakea.

Daign Dupanto and the crew thanks for those special moments and priceless footage that will always be there for our memory. All my friends and their families for making me feel at home in French Polynesia: Olivier and Laurence, Olivier Ravel, Jerome and Mehiti, Christelle and Tehotu, Jenny, Maina, Tepiu, Caroline, Marina, Nicolas Bonnard, Camille, Manu, Emile and Agnes, Thierry, Tia, Benjamin and Teiki, Ralph and family. Mireille and her family for taking such great care of my son.

Pierro Le Menn, Jean Michel Gué, Michel Boyer, Guillaume Cosculluela, Romuald Joncqua, Jean Sarthou, Bernard Choquet, Phillipe Marzat, Ludovic Strohl, Alain Benoit, François Liets and all my friends back in France for staying faithful despite my being on the road most of my life.

All the Tahitian surfers for making this journey so exceptional. You have made us dream so much over the last 10 years. I hope we were shouting loud enough during all your incredible rides.

Vetea David for being the original Tahitian waterman. I have followed your career with admiration from your earliest competitive years.

Manoa Drollet, the "Boss", a true surfing master: for giving the best surfers in the world a run for their money. I am so proud to be part of your team.

Raimana Van Bastolaer for being a great ambassador and always keen to go deeper.

Arsène Harehoe for being the nicest guy and still pulling in harder then ever.

Hira Teriinatoofa, Kevin Johnson, Alain Riou, Michel Bourrez, Marama Drollet, Steven Pierson, Patrice Chanzy, Heifara Tahutini, Heiarii Williams, Didier Tin Hin, Thierry Domenech, Evaina Germain, Nicolas Richard, and all the boys for sharing their passion with me.

All the riders that have pushed the limits at Teahupoo and contributed to the show.

When the conditions are heavy and the channel packed with people, boats and watercraft, the last thing you need is to be distracted by security aspects while you are shooting.

Emile Savoie for being able, when I am on your boat, to trust you with my life and equipment. You're the master.

And to all the boat drivers that I have worked with: Bjarn Drollet, Kin Kin Sandford, Eric Labaste, Tain, George Riou, AndyFrye, Hefara Dutertre, Moana David, Chris O' Callaghan, Gerard Benssoussan, Poto. Thanks for keeping us and others safe and in position. Without your expertise and dedication I would not have the images I have today.

The jet ski pilots and Tahitian Water Patrol for risking their lives and equipment positioning the surfers or doing rescues in the impact zone.

All the families and people down at Teahupoo for making the place so special.

The Parker family, especially Mamie, Heriing and Nellina and all their beautiful children and grandchildren.

Papie and mamie Maoni, Ben and family, Andrew and Warren Smith, Peva Levi.

All the other cameramen with whom I have worked over the years.

Tim Pruvost, Alex Borger, Eric Dupas, Benjamin David, Rick Jakovitch, Larry Haynes, Mike Prickett, Tomate Peralta, Nordu, Tim Bonython.

If I miss the shot, I know you'll have the footage!

Yannick Place for all the years you have spent documenting and supporting the Tahitian surfers with your articles in the local newspapers.

Pierre Lesage for the room with a view.

Polynesia Helicopter pilots, Marc Koska, Michel de Reneville, Alain Richard for helping me to get those shots. Teahupoo looks awesome from up there.

Michael Sebban for triggering the project. I owe you one.

All the editors and photos editors at Surf Session, Surfing Life, Surfer, Carve, Fluir, Surfer's Journal, Surfer Rule, Surfer's for your long lasting support. Especially Lee Pegus for a stellar performance as a photo editor.

Thierry Fouchet and Vincent Stuhlen at Oxbow for giving me the means over the years to produce some great Teahupoo footage.

Andrew Flitton at Billabong for backing our project and supporting the local surfers. Bushy and all the Billabong event crew for doing a great job every year.

Louie Egan for being the smoothest contest director around.

Photography:	Tim McKenna
Art direction:	Stephanie and Tim McKenna
Color correction:	Mike Gandouin - Nicolas Gandouin
Graphic artists:	An'so Le Boulc'h - Corinne Petit - Nicolas Gandouin - Graeme Murdoch
Text:	Guillaume Dufau
English translation:	Ross and Gillian McKenna, Denis Lagoeyte
Technical information :	Panoramic large format 6x17 : Fuji GX 617 Professionnel body with Fujinon Lens
	Medium format 6x7 : Mamiya 7 body with Mamiya lens
	Analog format 24x36 : Nikon F5, F6, F100 bodies with Nikkor Lens
	Digital format : Nikon D2X, D200 bodies with Nikkor Lens

Films Fuji Velvia - Kodak E100 VS - Kodak TMAX 100 - Agfa Scala

Bibliography

– Teuira Henry, 1951. *Tahiti aux temps anciens* ; Société des Océanistes, Paris.

– Takau Pomare, 1971. *Mémoires de Marau Taaroa, dernière reine de Tahiti* ; Société des Océanistes, Paris.

– Nolwenn Roussel. *Jardin de récif, sur la trace des premiers surfeurs tahitiens* ; Éditions Atlantica.

– Académie tahitienne – Fare Vana'a (www.farevanaa.pf)

– *Surf Session Magazine* (France): N° 120 (July 1997) N°159 (October 2000), N°161 (July 2001), N°180 (July 2002) N°188 (March 2003), N°192 (July 2003), N° 216 (July 2005).

– *Australia's Surfing Life* (Australia): N°142 (July 2000), N°154 (July 2001), N°203 (August 2005), N° 2007 (December 2005), N° 209 (February 2006).

– *Surfer Magazine* (USA): December 2000, December 2005

– *Surfing Magazine* (USA): July 1994, August 2003.

You can find Tim McKenna's photography on **www.tim-mckenna.com** and his fine art print collection on **www.tmk-poster.com**
© Tim McKenna 2007

First published in 2007 by Au vent des îles
mail@auventdesiles.pf — www.auventdesiles.pf
© Au vent des îles 2007

English Editions:
© 2007 White Star s.p.a.
Via Candido Sassone, 22/24
13100 Vercelli
www.whitestar.it
e-mail: whitestar@whitestar.it

All rights reserved. This book, or any portion thereof, may not be reproduced
in any form without written permission of the publisher.
White Star Publishers® is a registered trademark property of White Star s.p.a.

ISBN 978-88-544-0309-3

Reprints:
1 2 3 4 5 6 11 10 09 08 07

Printed by China